THE BEAUTY OF DIFFERENT

Observations of a Confident Misfit

bright sky press
HOUSTON, TEXAS

2365 Rice Boulevard, Suite 202,
Houston, Texas 77005

www.brightskypress.com

10 9 8 7 6 5 4 3 2 1

Library of Congress Cataloging-in-Publication Data on file with publisher.

Creative Direction by Ellen Cregan
Design by Marla Garcia
Printed in China through Asia Pacific Offset

THE BEAUTY OF DIFFERENT

Observations of a Confident Misfit

KAREN WALROND

bright sky press

HOUSTON, TEXAS

FOR MARCUS AND ALEX

Contents

beauty

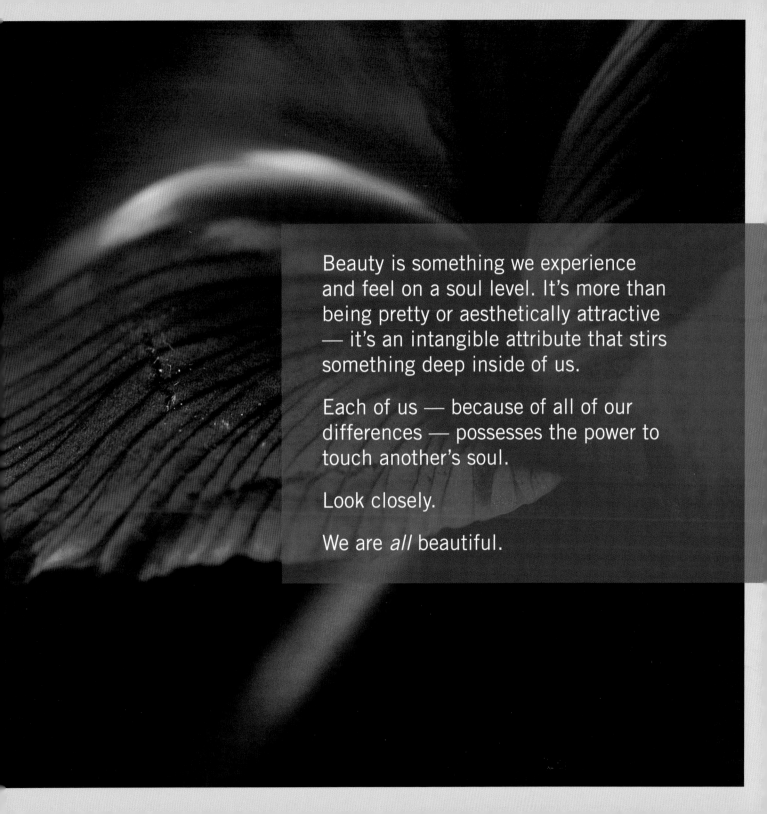

Beauty is something we experience and feel on a soul level. It's more than being pretty or aesthetically attractive — it's an intangible attribute that stirs something deep inside of us.

Each of us — because of all of our differences — possesses the power to touch another's soul.

Look closely.

We are *all* beautiful.

foreword

When I was about eleven years old, my family moved from our tiny island home of Trinidad, located just off the border of the South American country of Venezuela, to the relatively large town of Kingwood, located just off the border of the Texan city of Houston. I remember going to school that first day, with my short afro and sensible shoes, staring open-mouthed at the Kingwood Girls with their long, elaborately styled hair, tight blue jeans, lip gloss, pink bubble gum and high heels.

The Kingwood Girls were one of my first exposures to Different. In their defense, I was probably pretty odd looking to them, as well. So naturally, they stared right back.

In response to all this gaped-mouth staring, I reacted as most eleven-year-old girls would, I suppose: as much as humanly possible, I did everything I could to look like them. I talked my mother into buying me tight jeans, lip gloss and high heels (or as high as my no-nonsense mother would allow). I grew my hair, straightened it and wrestled it into "wings." I officially began my long career in Trying To Be The Same.

I am embarrassed to tell you how many years I spent working at this career.

However.

At some point, I grew up. I got educated. I got a job and I traveled. I met people who looked different from me, sounded different from me, loved different from me. I saw buildings different from the ones in my neighborhood, ate food different from my favorite cuisines, smelled different aromas, touched different things. I began to seek Different, taking note of it. Writing it down. Photographing it. Celebrating it.

Because after all those years of Trying To Be The Same, I had finally discovered that Different is

very,

very

beautiful.

What follows is what I found.

of individuality

"Be Yourself. Life is precious as it is. All the elements of your happiness are already there. There is no need to run, strive, search or struggle. Just be."

Thich Nhat Hanh

Views on Individuality

For several years now, I've been on the constant lookout for Individuality. Whenever I go to a party, one where I don't know a soul, I find myself surveying the room searching for someone, anyone, who looks like they might be interesting, approachable and very, very cool — and yet, not so cool that they are firmly in the realm of haughty, mortified to be cornered into talking with someone the likes of me. Even though I certainly don't go to parties nearly as often as I used to — a side effect, I suppose, of being mother to a young child who can't … or at least *shouldn't* … be left home alone — I've noticed that every time I go out, I fall into the very same pattern.

Recently I attended a celebration dinner held by a bride and groom the night before their wedding. The odd thing was I didn't know either of them. An out-of-town guest — the bride's cousin, and a good friend of mine — had flown in for the festivities. My friend wasn't going to be able to spend much time with me while she

was in town because she was busy photographing the wedding, so she invited me to come to the party. I therefore found myself standing at the doorway of a home I'd never visited, clutching a bottle of what I hoped was a decent champagne.

(I wonder, exactly, how do you know if you've purchased a decent champagne? The bottle I bought was of an average price — not the cheapest in the specialty food store I'd dashed into prior to arriving, but certainly not the most expensive — yet, I suspect price isn't always the best indicator of taste.

But I digress.)

Once I was invited in, I began my usual habit of scanning for an Individual.

What is somewhat ridiculous about this whole scene is that I'm not entirely sure what I was looking for: after all, I don't have a Party Type. What I'm seeking isn't physical beauty — sure, attractiveness is nice, but it's not like I'm looking for a date. I do know that if he's dressed differently from everyone else in the room, this is a plus. If she's watching the setting with an air of intrigued-yet-detached confidence, bonus points. And if the words *quirky* or *odd* could be used to describe the person, I might just buy him a drink.

My fascination with the unusual or different isn't confined to people; I've always been drawn to places and things that are singular, as well. But really, aren't we all? Given a street full of houses with blue doors, save for one with a red door, 98.3 percent of us will be intrigued by the red door. *What's behind that door?* we think. *What could've possibly possessed the homeowners to paint the door red? Are they artists? Separatists? Just plain ornery? Or maybe it's some sort of sign, a secret code that only those who have red front doors could possibly understand. I'd really like to knock on that red door.*

I want to see what's inside. I bet the home is full of nothing but end tables … and on and on we continue, creating wild fantasies about the possible personalities of the people with the red door. We can't help ourselves. Curiosity is, after all, human nature.

Still, it's surprising — downright startling, really — that given this irresistible enchantment with the different, so many of us desperately try to be exactly the same as that which we found unique in the first place. I remember several years ago, an actor in a wildly popular television show cut her hair in a particular way. Suddenly every woman I knew between the ages of twenty and thirty-five with straight hair hightailed it to her stylist, breathlessly asking for The Rachel or The Britney or The Tiffani or whatever the character's name was. I even had some curly-haired friends in the mix, too, paying hundreds of dollars to beat their hair into straight submission. None were

immune. During that time, I remember going to meet a friend of mine at a bar, and I walked right past her in a confused fog: there were so many women in the room with the same haircut. When I finally found her, with her fashionable hairstyle and the pretty cocktail she had thoughtfully purchased for me while she waited, I gulped my drink uneasily, trying to shake the feeling that I'd just walked out of a bad Stanley Kubrick film. I learned that night that I find too much sameness unnerving.

And so, it naturally follows that unique people are intriguing to me. It takes guts to declare yourself an individual and live your life accordingly; backbone to dye your hair a color that doesn't actually occur in nature and wear it unapologetically; courage to create one-of-a-kind art and put it out there, damn the reaction. Who wouldn't be attracted to that kind of bravery?

So, you're probably wondering what happened after I walked through the door with my bottle of iffy champagne. Well, it turns out the person who most captivated my attention that night was the bride. Smart, funny, confident, she warmly welcomed me with an arresting smile and thanked me profusely for my gift.

Also, on touring her home, I discovered she had the most amazing collections of clowns and dentures that I have ever seen.

No wonder her groom finds her irresistible.

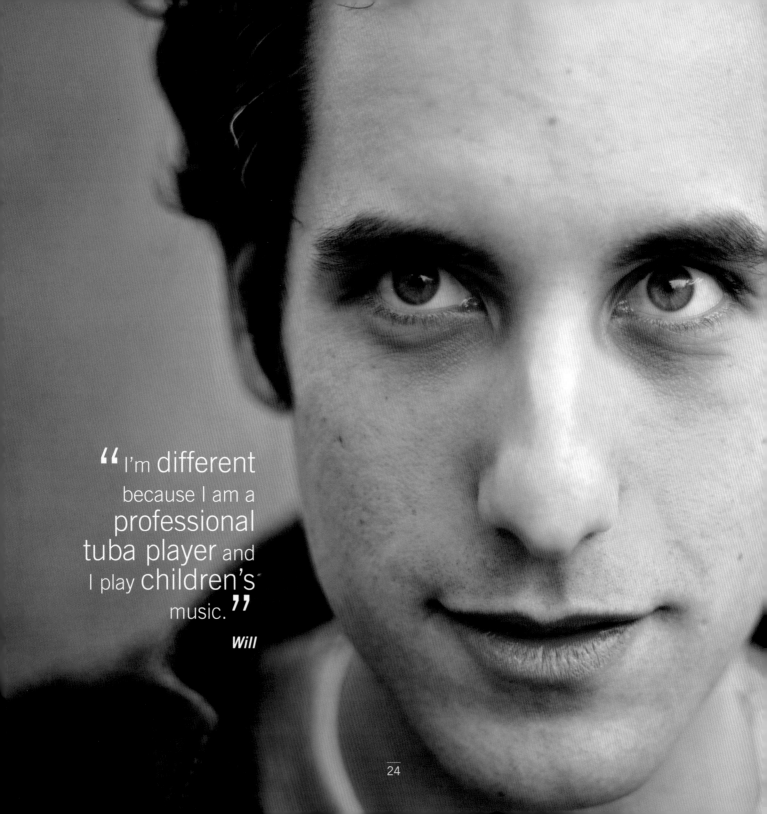

" I'm **different** because I am a **professional** tuba player and I play **children's** music. "

Will

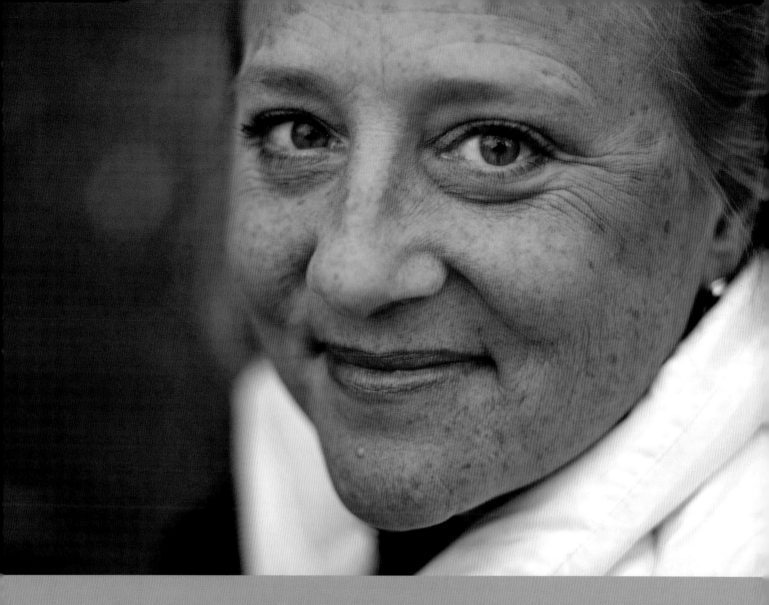

"I'm **different** because the fact that I was **adopted** has always made me feel that **I was chosen.** For this reason, I also feel I've been chosen to **make a difference.**"

Alison

" I'm different because I'm a successful Hispanic female excelling in a predominantly male industry. **"**

Maxine

" I'm **different** because I have a **unique sense** of style, and I'm **not afraid of** wearing **Smurf-blue** shoes in public. **"**

Matt

A Closer Look: Helen

Despite my strong attraction to unique individuals, I've spent an unfortunate amount of my life trying to blend in. Perhaps it was that need that I felt in junior high to keep from sticking out like a sore thumb, or maybe it was that "good girl" syndrome that afflicts so many firstborns; regardless of the reasons, I've spent most of my life ensuring that I did what I was supposed to do. Sometimes my parents were the people I tried so hard to please; other times, I worked hard to meet the approval of classmates and teachers, and later, bosses and coworkers. It doesn't matter, really — the upshot was that for most of my life, I looked and sounded and acted exactly as someone with my background and education "should." While I always took smug pride in this fact, I secretly envied those who marched to their own drums. Oh, I might have *pretended* to feel superior, to look at those who dressed and acted differently as members of fringe society. But the truth was that I found people who developed their own looks, styles and down-to-earth, honest personalities enviable.

And, you know, intimidating.

When I first saw Helen — she of the purple hair, tiny frame, funky glasses, determined manner and stubbornly English accent — she scared the hell out of me. It was a little over ten years ago. I had just begun working at a large, conservative Fortune 200 company, my first full-time corporate job after completing law school and passing the bar exam. I remember that first week of work, as

I unpacked my university and law school diplomas — because as a relatively new lawyer, I still felt very strongly about displaying them prominently — I would watch Helen rush past my office, her face furrowed with thoughts of Very Important Things. She would stop in the hallway, speaking assertively to executives not quite twice her age (and certainly far more than twice her size), and then suddenly burst into low, unbridled laughter before quickly turning to other topics of immense gravity. When Helen and I were finally introduced, she was friendly, but businesslike; niceties were exchanged, and she quickly returned to her work at hand. As she made her way back to her office, I felt a mixture of mild terror and crushing admiration: I secretly wished I could be her, or at the very least, be her friend.

Over the past decade, I've learned that while Helen is still all those things I thought when I saw her on that first day of work, she's also genuine, spiritual and unwaveringly down-to-earth. She has a heart that is both vast and deep. But what has always struck me about her is how unapologetically she maintains her individuality.

In a sea of men in suits, khaki trousers and golf shirts, Helen strode into every business meeting with her shocking, deep purple, cropped hairstyle, her brightly colored clothing and her quick smile, her air of complete competence and a keen intellect to back it up. (You haven't truly lived until you've watched the faces of conservative, khaki-clad, middle-aged men as a woman with purple hair walks into a serious business meeting. Everyone should witness this at least once.) And Helen's nonconformity worked: a couple of years ago, this same large, conservative, male-dominated Fortune 200 company asked her to appear as the sole spokesperson in a national television commercial on the organization's behalf — a company, by the way, that was trying to salvage its public image and believed that Helen was just the woman to help make it happen.

Helen and I are now good friends, but one day I realized that in spite of our friendship, I really knew very little about how she came to be so unapologetically original. So, out of the blue, I asked her if she would spend some time with me and let me ask her an obscene number of intrusive questions. Luckily, we're close enough that she said yes.

We drove together to a local café one muggy morning. It never ceases to amaze me how uncomfortable I find Houston summers. The damp heat that seems to smother the city from mid-April through late September is incomprehensible, even to someone like me who spent most of her formative years living in a tropical rainforest. Despite the heat and humidity, we made the decision to sit outside with our hot drinks. We made our way past a wall covered with flowering jasmine to a large outdoor patio, filled with urban hipsters with their lofty intellectual books, their babies sleeping fitfully in hot slings and an occasional yappy dog.

We settled into our conversation, Helen looking as calm and composed as she always does — she's the type of person who makes you want to show off your best self (which, frankly, is not the easiest thing to do when the sweat starts to prickle the back of your neck). She told me about her father, her mother and her sister. When I pressed, she mentioned that her family wasn't particularly demonstrative when she was a child. For this reason, she said, they aren't very close-knit now.

I asked gently if she regretted it.

"I don't bother with regrets," she said immediately. "It is what it is."

It is what it is. I nodded in agreement. This is such a simple sentence, but it has taken me years to embrace this concept in my own life. When I consider how I live my life today — as a writer and photographer — it is so different from when I started my formal education in engineering, and then law school, twenty years ago. As the firstborn daughter of a man with a PhD in engineering and a thorough fascination with mathematics, I believed that the only route in life I was supposed to follow was a technical one. My father certainly also harbors a true passion for the arts, one he tried doggedly to instill in my sister and me, but from all our family day trips and experiences to museums and symphonies, I developed a deep-seated belief that practicing the arts was only for the truly prodigious, which I certainly didn't consider myself to be. No, I was an engineer's daughter and so an engineer, and later, an engineers' lawyer, I became.

But I've never been happier than I am these days making my living in a more artistic way; and yet, I have absolutely no regrets about the twenty years I spent living my previous life. At the café, Helen confirmed she felt the same way about her past: "When I was about eighteen years old, trying to decide what I wanted to do with my life — whether to go to university, or something different — I had a teacher who told me 'there's no such thing as a wrong decision.' He said that we all simply make decisions, and from there, we make more decisions based on our previous ones — but really, there are no wrong decisions. He's so right."

We continued talking, the sun getting warmer (and me getting sweatier). As I learned more about her, I discovered we also shared another similar experience — in our twenties, we both endured a particularly dark time, a sort of crisis of identity. In my case, right before I took the bar exam, my marriage crumbled; soon after, I was laid off from the job I was supposed to have for the rest of my life — or so I thought. It was a horrible time, and I found myself spinning, unsure of who I was, or how I found myself in such an uncertain, unfamiliar place. I lost weight, I became depressed. Helen's experience sounded so much the same: "Everything fell to pieces," she said.

"So, how did you make it out of your dark time?"

"Well," she began slowly, "there are really only two choices when you get that low, aren't there?"

I wasn't satisfied.

"Yes," I persisted, "but not everyone chooses to get better. Why did you get better?"

"Well," she began slowly. "I finally figured out that I'd been searching for answers outside, not realizing that all of the answers were actually inside of me. And that trusting myself, my own higher power, would make it all okay. I spent a lot of time examining what's inside of me, and I know when I'm struggling with something, when I finally feel a deep sense of calm, that's when I know a decision is right for me. I just know.

"I started working with a mentor who led me through an exercise," she continued. "She asked me to list my most positive attributes, which at first was very hard. But eventually, I came up with a list, and she read them back to me, like she was introducing me to someone with the same characteristics. It was really pretty powerful: it was the first time I really began thinking positively about myself."

I love this concept — the idea of thinking of yourself in an objective manner, rather than a subjective manner. So often we're our own harshest critics; at the very least, I know this to be true of me. Yet, if probed, we can all think of something we're proud of, some characteristic of ourselves that is good, and true. We've all had an occasion to be complimented, to be told that something we made, thought, did or said was appreciated. It occurs to me that focusing on these attributes of ourselves — that stepping outside of ourselves and paying attention to these characteristics closely and critically — isn't an act of narcissism as much as it is an act of introspection. These characteristics are our Different. They're our superpowers.

As Helen and I talked further, she told me about a tool that she would use to help her focus on her inner spirit, to help hone her superpowers. "I used to keep a file folder where I would jot down anything kind or complimentary that someone said to me or about me. If I ever started feeling down," she explained, "I would go back

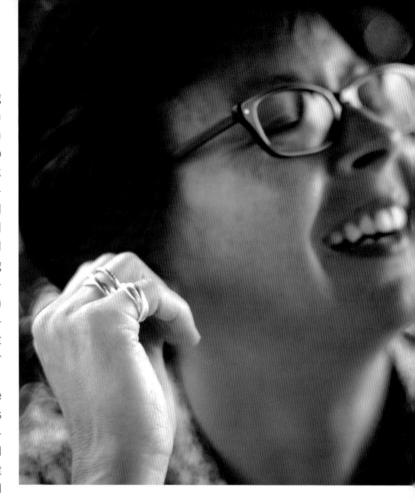

and read through the notes that I'd added to my file. I haven't had to use the file in a long time, but it was so helpful."

I asked Helen if she noticed whether her newfound focus on authenticity and individuality had an effect on those around her — for example, did she notice a difference at work?

"I believe, as a result, my career took off," she said.

"Really?" I shook my head in disbelief. She and I had worked in the same conservative industry for many years — an industry which, in many respects, historically valued conformity in its employees over individuality. "How so?"

"Well, it's very energy-intensive to constantly try to second-guess what it is people — bosses, managers, coworkers or even friends — are expecting of you, or how they want you to behave, or how you should look or act. I found that by focusing on my own inner strength, I was able to determine with far more clarity what I wanted out of my own career and my own life. Therefore, I was able to take a more active role in the shape of my own

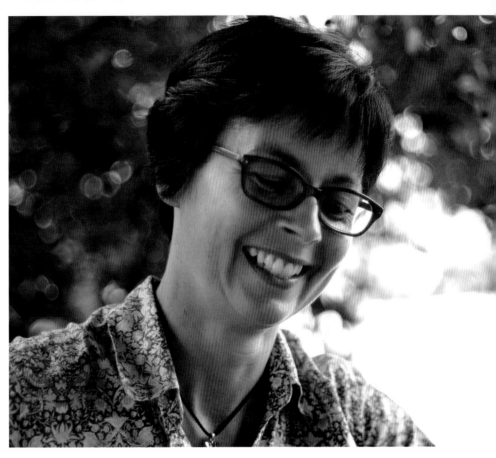

career path. By staying true to what felt authentic to me, I was able to focus on things around which I had passion, and therefore I was more successful."

"Do you think people respected you more because of it?"

"I have no idea if people respected me more," she responded without hesitation. "The point is, *I* respect me more. And really, that's what counts, for me."

Her comment was so simple, and yet so profound. For while I certainly feel I have a healthy amount of self-respect, if I'm honest, I think I got here more by accident than by design. Imagine what might happen if we all began living our lives by using our respect for ourselves as a constant guiding point — I suspect our lives would change immeasurably for the better.

We continued talking, Helen and I, her words providing me constant food for thought. Gradually our conversation turned to our children, and she surprised me by telling me that she had spoken very little about the kinds of things we were talking about on that hot Texas day with her son, Conor. "Why?" I asked, somewhat surprised.

"All of this seems so powerful."

"Well, I definitely try to teach Conor to understand his own feelings and listen to his own inner voice. But I don't teach him in any formal way. As parents, we can just sow seeds, right?"

I mulled this over, as I finished the last of my now-tepid cappuccino. It had never occurred to me that the concept of being an individual could be taught to others in any way but a direct one. With my own daughter, I found myself sometimes going out of my way to make her realize how special her unique characteristics are, how special her spirit is. The idea that there might be a subtler approach to achieve the same objective was novel to me. The more I thought about it, the more I realized that what made Helen's nonconformity so appealing was that she didn't talk about what it was that made her different, or why she thought or looked different; she wasn't on a crusade or rebelling or trying to make any particular statement. She simply summoned her inner strength and intuition and therefore conveyed complete comfort in herself.

I finally spoke. "Is there anyone in your life you look up to or admire or try to be more like?"

"I … I don't know. I don't think so. I mean, I admire lots of people for lots of different traits, but when it comes down to it, there's no one in my life who I wish I was more like. I used to live my life wishing I was like other people, but then I realized that was just me comparing their 'outsides' to my 'insides,' you know? When I could finally get past what everyone might be thinking about me, I realized that ultimately I could only live my life, and I just wanted to live in humility, in honesty and be true to myself.

"And if I did that, in the end, everything is going to be just fine."

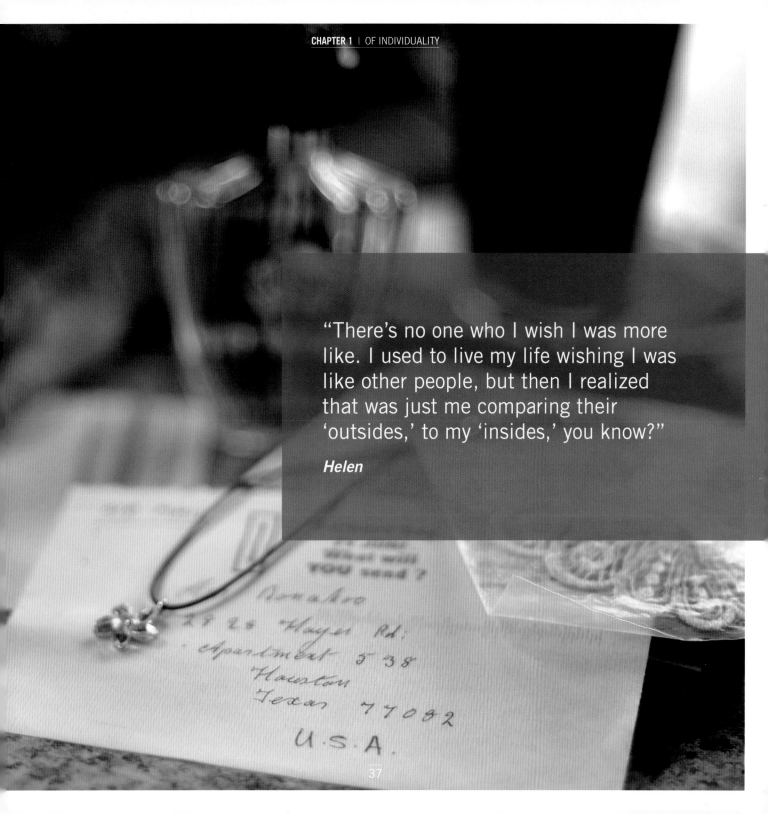

"There's no one who I wish I was more like. I used to live my life wishing I was like other people, but then I realized that was just me comparing their 'outsides,' to my 'insides,' you know?"

Helen

Whip It

One Saturday morning, out of the blue, my five-year-old daughter called out to me from her bedroom:

"Mom? Can I have a whip, like Indiana Jones?"

I didn't even attempt to hide my immediate amusement: I burst into laughter. "Absolutely not, Alex," I said, through giggles. "There will be no whips in this house.

She laughed as well and didn't push the subject. Still, I can't help but wonder if I answered her properly. Perhaps I should've asked her why she wanted the whip. Maybe the whip was somehow related to her dreams about her future. Did she fantasize about one day being an intrepid anthropologist like Indy? A fearless lion tamer? A dominatrix?

While I hold firm on my decision to keep our house whip-free, maybe I should pay a bit closer attention to the clues she might be giving me to her own identity. And perhaps, when I experience my own fleeting whims, I should pay closer attention to the clues they might give me to mine.

Metamorphosis

It's easy to fall into the habit of doing what you feel you're supposed to do, as opposed to doing what you feel you were meant to do. And it occurs to me that the secret to metamorphosing into exactly who we are meant to be — as opposed to who we think we ought to be — is to take a moment when we're struggling to be still and *listen*. It's not always easy, but it is possible. It just takes conscious, determined practice.

I can't always do it perfectly, but I'm getting better.

And if I can do it, anybody can.

of spirituality

"We are not human beings having a spiritual experience, we are spiritual beings having a human experience."

Pierre Teilhard de Chardin

Views on Spirituality

Religion, spirituality. Spirituality, religion. For most of my childhood, I assumed that these words were interchangeable. But as I've grown older, I've started to understand that they can be very different.

My relationship with religion is complicated. I was raised Catholic, by a Catholic mother with somewhat strict Catholic ways. Like many Catholic families, we didn't eat meat on Fridays, except fish or other seafood dishes. Like every good Catholic six-year-old, I donned my pretty (read: itchy) white dress and made my First Communion. At age eleven, I made my First Confession (which included making up a few sins on the fly, just to make my admissions a bit juicier for the long-suffering priest. That's right: I'm a giver.) By thirteen, I was confirmed into the Catholic Church. And through it all, there were certain aspects of my religious upbringing that I loved: I always enjoyed the smell of the incense in the church, the taste of the Holy Communion wafer and feeling slightly naughty as I sipped the wine. The predictability of the Catholic rituals was familiar and comforting, and I continued to attend church well into my adulthood, more as a habitual exercise that was "good for me" — like jogging, say, or eating all my vegetables — than arising from any sort of spiritual need.

As is probably true of many people in their early twenties who have been raised with organized religion as a part of their lives, I began to wonder why I was going to church in the first place. I had developed questions and become uncomfortable with some of the tenets of the church — the fact that women were not permitted to be priests, for example — and while I never got to the point of questioning the existence of a god or the supernatural, I did begin questioning the need for organized religion. *I can totally do this myself,* I thought. *I don't need some old priest who has never been married or had sex to tell me how to live my life.*

Do it myself: I certainly tried. I began to read everything I could get my hands on about all types of religions — Christianity, Buddhism, Taoism, Hinduism — and became intrigued by the various rites and liturgy offered and practiced by each one. The more that I learned about religions that, on their faces, seemed foreign to mine, the more I learned how much they are the same. And the more I became comfortable in my own beliefs.

Reading all of these texts, I began to think about the people in my life who I considered strong spiritual influences. I thought of the young nun in Trinidad whom I met while I was still attending my convent high school. She had such a gift for storytelling. She told parables taken straight from the Bible, but she would do so in Trinidadian vernacular, making them come alive for me for the very first time, even though I'd heard them on countless occasions during Mass over the years. I thought of the priest in Trinidad who was also fond of local slang (and local bars) and would talk about the spirit of the people he would meet in villages and rum shops, and how their encounters would enhance his own spiritual growth. They were members of the clergy, but over time, I've also encountered laypeople who weren't to be spiritual leaders, possessing a gift of inspiration — from whom I also believe — the yogi who spoke of the creation and composition of music as an ultimate, universal form of meditation, to my sister-in-law's husband, Nigel. Nigel is a devout Christian with a wicked sense of humor, an insatiable need to rib everyone around him, and who rarely speaks openly outside of his church about God or religion; and yet, during a quiet moment on my wedding day, took my hand, looked at me with great kindness and quietly said, "God bless you and Marcus." I was so moved by this simple gesture, particularly because Nigel and I really didn't know each other all that well at that time.

Only after meeting this broad array of teachers have I come to understand the distinction between religion and spirituality. While I respect organized religion and what its tenets and rites can teach, I've always been more drawn to people who exude a strong sense of spirituality, whether these individuals are members of the cloth or laypeople, or even people who choose not to practice any religion at all. Some are people who are mindful about every moment of their day, even as they good humoredly tease their children or fraternize with the local barflies. Others are individuals who, even if they do not believe in a god, are intimately familiar with the concept of loving-kindness and treat everyone accordingly. Or there are those who may intuitively believe that there's something bigger out there and actively bring the supernatural into each moment of their days. But most importantly, all these people innately understand the humanity within themselves, while honoring the divinity within others.

As I said, my relationship with religion is complicated. Though I rarely go to church these days, I say a prayer of thankfulness every night and teach my daughter to do the same. I try to meditate, but I often forget.

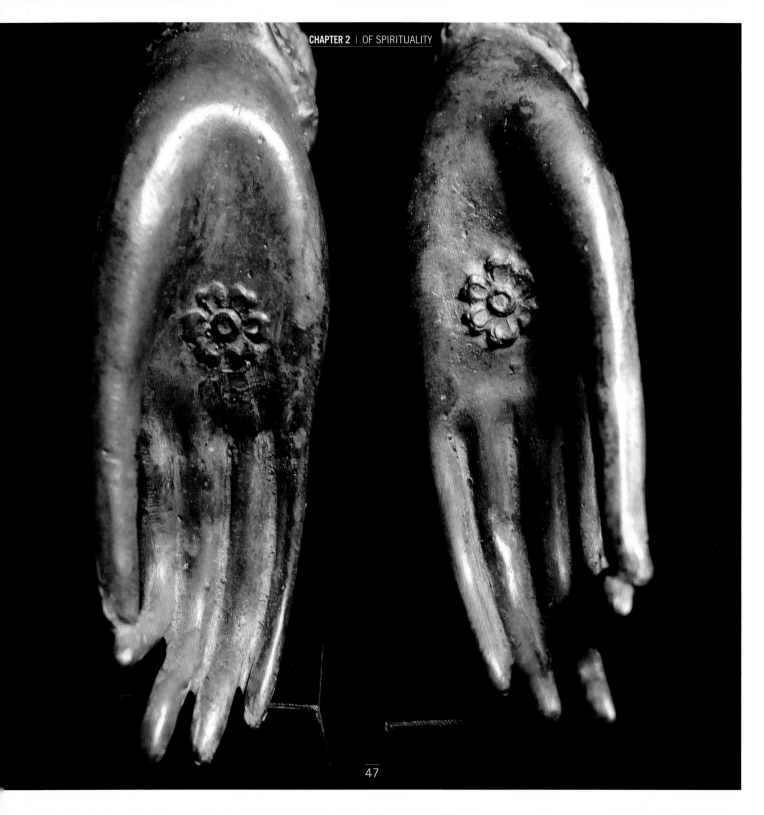

I don't eat meat or seafood on Fridays anymore, but that's because I'm a vegetarian now. And in our home, we do honor some (but not all) of the holidays of my Catholic upbringing with both solemnity and celebration.

And when I do, very occasionally, wander into a church, I'm still comforted by the smell of the incense and the taste of the Holy Communion wafer.

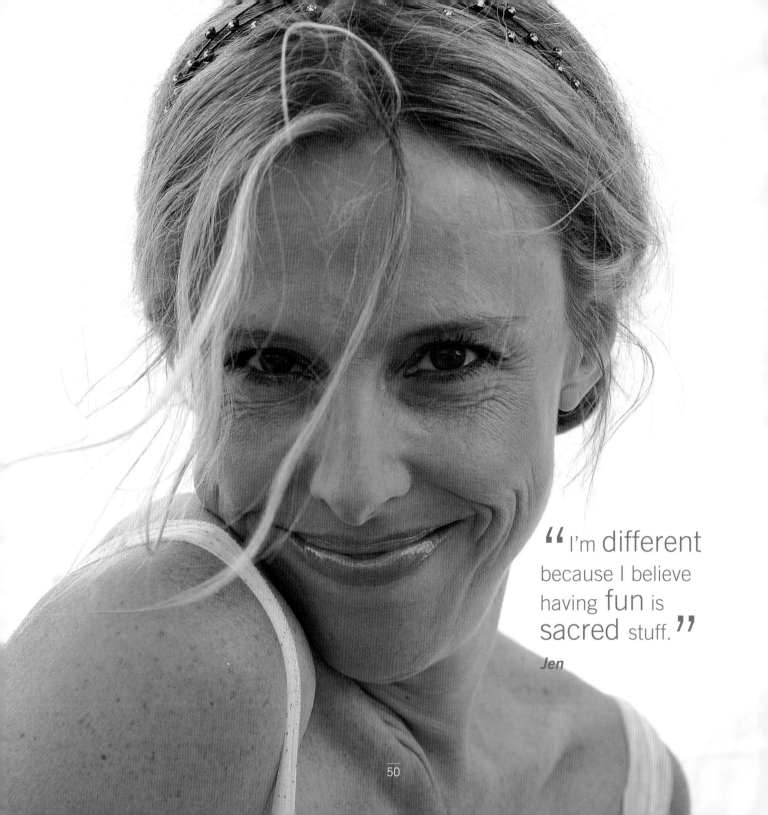

" I'm **different**
because I believe
having **fun** is
sacred stuff. "

Jen

" I'm different because I'm happiest when it's raining. The sound of raindrops falling has the same physical effect on me as being still and taking a deep breath. "

Heather

" I'm different because once I begin to love someone, I never, ever, ever stop. **"**

Denise

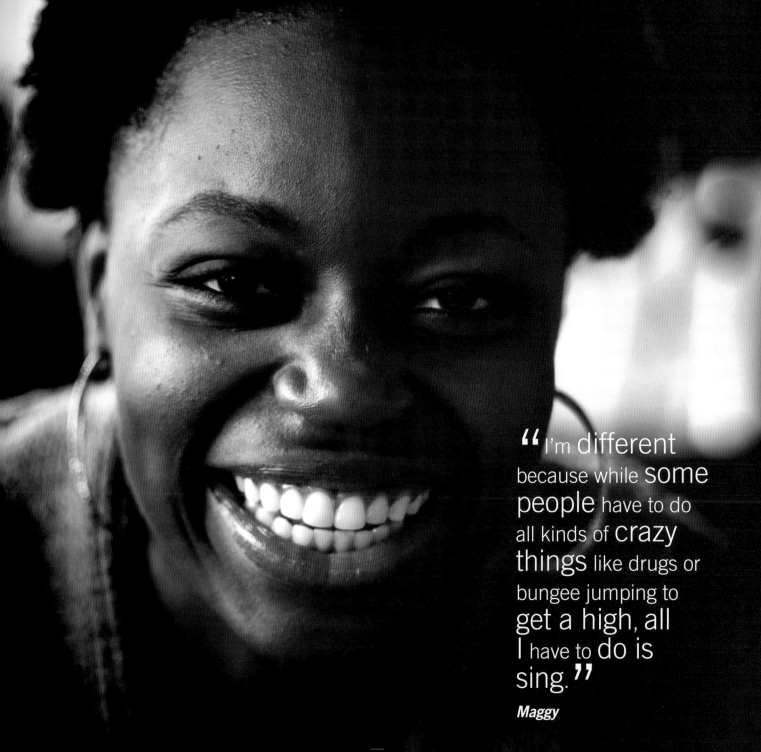

“ I'm **different** because while **some people** have to do all kinds of **crazy things** like drugs or bungee jumping to **get a high, all** I have to **do is sing. ”**

Maggy

A Closer Look: Patrick

I never thought that I would ever become friends with a priest. Having spent a substantial portion of my teenage years attending an all-girl convent school, I had grown to believe that priests were people to be respected, but never befriended. Priests were, frankly, somewhat alien. People to be feared. And besides, I found it cold the way they could make me feel badly just by listening to my confession ("You did *what*? That's five Hail Marys for you, young lady …"). Sure, I supposed priests could conceivably be nice people; even so, it never dawned on me that they could ever have any *real* friends. And by "real friends," I mean friends who were not also members of the clergy. Or, you know, not God.

Then several years ago, while waiting for our daughter to be born, I was struck with the sudden desire to find a church home for our growing family. Even though I hadn't been attending church regularly for years, I began a weekly habit of visiting churches in our city. On one particular Sunday, I visited a large Episcopal church, and while there, I distractedly filled out one of the "visitor" cards that had been placed on each pew. Within twenty-four hours, a priest called to ask me if he could answer any questions I might have. I was stunned: I didn't think anyone

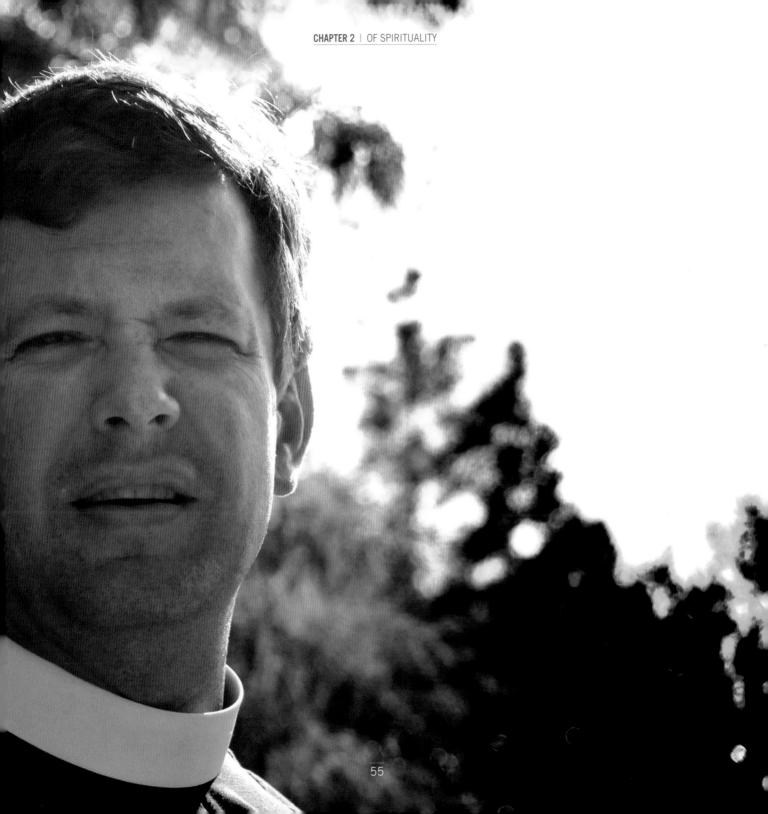

actually paid attention to those visitor cards. I'd only filled one out because I was bored, and writing in the little squares gave me something to do. As he spoke, I stammered my answers and then, after a few moments, he invited me to join him for coffee to continue our conversation. I was skeptical: I didn't particularly want the high-pressure sales job (or guilt trip) that I suspected would likely come from a tête-à-tête with a priest. But it felt even more wrong to actually reject a priest, so naturally — and nervously — I agreed.

"Wait," I said, before hanging up the phone, "what do I call you? 'Father Patrick'? 'Father'?"

"Just 'Patrick' will be fine," he said. I sensed he was smiling.

A few days later, I made my way to the coffeehouse where we'd agreed to talk. I admit I chose our meeting spot as a bit of a test: the space, while warm and welcoming, was located in a part of town known for its tattoo parlors and alternative clubs. I was fiendishly curious to see how a stodgy old priest would react to being met in a somewhat questionable neighborhood.

When the tall man approached me at the coffeehouse wearing his clerical collar, my first thought was *he's young*. He grinned, extending his hand. "I'm Patrick. Are you Karen?"

I smiled back. "I am."

He motioned to an empty table, and we took our seats. It was then that I noticed his wedding band. *Of course,* I mused. *Episcopalian priests can marry.* We immediately launched into a discussion of our families: I learned of his law student wife and young son; I told him about my software consultant husband and the upcoming adoption of our baby girl. I found out Patrick was interested in politics — and with certain issues, he wasn't always on the side that you would expect a priest to be staunchly on. He made me laugh, both with genuine admiration and mild surprise. At one point during that initial conversation, I remarked cautiously:

"Um … you're not much like most priests I know. Do you ever get in trouble for some of the things you say?"

"All the time," he said, with a shrug.

It turns out Patrick came to the priesthood relatively late in life. I asked him at what point in his life he knew he was going to become a priest, and he answered, "When I was about thirteen. I remember telling God that I would become whatever he wanted me to become and distinctly knowing at that moment that I should become a priest. And I didn't like it one bit. First of all, in my young mind, priests didn't make any money; and secondly, I didn't believe that any woman would ever want to marry a priest. So I spent the next seventeen years doing whatever I could — drinking, partying, whatever — to prove God wrong."

I smiled. "But you kept going to church the whole time?"

"Oh … yes, definitely. I've always had a strong faith."

Eventually, after university, a stint in acting and working as a youth minister in an Episcopal church in Connecticut, at the age of thirty he decided to enter seminary school, finally succumbing to the call he'd felt seventeen years earlier. And while he was in seminary school (as if God wanted to give him one final "I told you so"), Patrick met and married his lovely wife, Allison. As I listened to Patrick's story, I couldn't help myself: I really liked this guy. So when our daughter Alex was finally born, I didn't even hesitate to ask Patrick to perform

her christening.

Over the years, Patrick and his family have become friends of ours — even though my family still rarely attends church. They've been to our house for summer dinners; we've been to theirs to watch political debates. His keen sense of humor means that our conversations are often peppered with tongue-in-cheek jokes and wry life observations; yet, when we say our goodbyes, it's not uncommon for him to quietly make the Sign of the Cross on my daughter's forehead and bless her. I've learned that for all Patrick's apparent irreverence, he is a devoted husband to his wife and father to his two children, a great and kind counsel and a man of deep faith. And as I really began to reconcile my previous perceptions of the priesthood with what I knew to be true about Patrick, I realized that he was the first religious leader I'd ever met who demonstrated the value of focusing on the inner spirit as a practice separate and in addition to that of the practice of organized religion.

So I suppose it shouldn't have surprised me as much as it did when I learned Patrick was a boxer. But it did.

Because I was insanely curious, I asked if I could accompany him one day to the boxing gym to photograph him in action — as well as to try to figure out why he's so drawn to the sport. I think he was surprised at my request, but also pleased. Still, while he was eager to have me visit, he was also full of warnings: "Okay, Karen, just so you know, this is a real boxer's gym. This ain't Tae Bo." And there's no air conditioning, so dress to sweat."

"Got it," I said. "So, when I come out there, will I get to shoot you sparring?"

"Oh, I don't spar," he said quickly. "I *want* to spar. But I don't."

"Why not?"

"They won't let me." There was a note of regret in his voice. "No one wants to hit the priest."

Yeah. Can't say I blame them.

On the appointed day, a record-breaking hot, humid morning, I got into my car and drove into downtown Houston to the boxing gym. As promised, the gym was in a dilapidated brown brick building, right next to a dodgy-looking bail bondsman's office (and here I'd worried about the seediness of that coffeehouse five years earlier). I parked my car next to Patrick's and began looking for the "hidden doorway" he'd mentioned when giving me directions. Once I found it, I climbed the stairway inside, and walked into the hot, unairconditioned gym. It was an old building, with yellow walls and two boxing rings in the middle of the room. A clock timer hung on one wall, and every three minutes, the bell would loudly ring, presumably signaling the end of a round. Every wall contained a row of posters, each heralding a fight gone by between various boxing superstars — local and otherwise. In the middle of the gym stood Patrick, hands taped, dressed in workout gear and wearing a huge grin.

"Glad you could come," he said. "Here, let me show you around."

He gave me a tour of the gym — past the speed bags, the heavy bags and the other boxers jump-roping. He introduced me to his coach, Bobby, a lean young man with serious eyes with whom Patrick has developed a strong relationship over the years. As Bobby helped Patrick lace his boxing gloves on, I couldn't help myself:

"You know this is weird, right?"

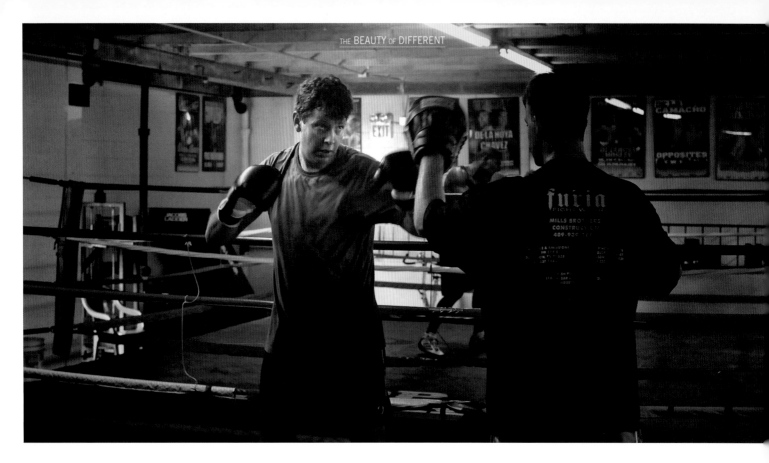

"What?" smiled Patrick, "your being here?"

"No!" I exclaimed, "This! All of this!"

"Boxing isn't weird," shot back Bobby, somewhat defensively. "Boxing's great!"

"No, no, not boxing," I quickly clarified. "It's not boxing that's weird. It's *Patrick boxing* that's weird. I mean, come on, he's a priest!"

"Oh, he's not a priest," laughed Bobby. "Not in here, anyway. Come on, let's go."

The men climbed into the ring, Bobby donned his punch mitts, and for three-minute series, Patrick practiced his jabs and blocks while Bobby murmured coaching cues and encouraging advice as he deflected Patrick's blows. Every three minutes the bell would ring, and Patrick would stop for a rest, glistening with sweat. It was during these rests that I started peppering him with questions.

"Seriously, Patrick, why boxing?"

"Why not boxing?" he countered.

"Well, for one thing, it's violent. And if you wanted exercise, you could have chosen to do what other priests do. Like, I don't know, jog."

"I have bad knees."

"Okay, then, swim."

"Too boring."

"Okay, fine," I said, exasperated. "Then what is it about boxing that attracted you?"

Patrick was silent for a moment. Then, suddenly: "Have you heard about shadow beings?" This is typical Patrick, a consummate storyteller. I played along.

"No. I can't say I have."

"There's this theory — Carl Jung, I think — that says that we each have 'shadow beings.' There can be golden shadows and dark shadows. It's like how we each have within us divinity, or God, and we have mortality. Anyway, the theory says that these dark shadows — our mortality, our humanity — can consume our everyday life; however, if we pay attention to them, then they're appeased, and they leave us alone to live closer to our divinity.

"For me, my dark shadow is anger, so I box to pay attention to it. By paying attention to it three times a week, for two hours each session, it's appeased. And then I can live my day-to-day life with less anger. I started boxing as a strategy for helping me deal with conflict."

This idea of 'shadow beings' intrigued me. Frankly, the thought of paying attention to my dark side is not one I particularly relish. But it makes sense: in order to know our entire selves, our entire spirits, it seems logical to not only cultivate our best selves, our superpowers, but also to acknowledge our worst selves, explore the darkness, and learn how to "appease" them. It seems prudent to try to understand all aspects of our spirituality, positive and negative, in order to grow into our best selves.

The bell sounded, and Patrick returned to the ring. I watched as he focused, blocking out all other distractions except for his target and the sound of Bobby's voice guiding him through the round. "Rev it up, Frat Pat." And Patrick would respond in kind.

During a break, I asked:

"So you started boxing to help you deal with conflict. That makes sense. But have there been other benefits?"

"Well, I've lost twenty pounds," he grinned. "But yeah, I love boxing because of what it teaches me. I love how it's so completely an allegory for life."

I asked him how.

"Just being around these boxers, there's a certain wisdom and ideology that I hear as they relate to each other. So much of it can be directly applied to life. There was a group of us, once, watching two boxers spar in the ring. One of the boxers got hit, and he sort of stood there, stunned. And one of the spectators just smiled. He said, 'This is boxing, man. You're gonna get hit.'

"Really, if you think of it, that's just like life. Things are going to happen to us, and they're going to seem like they came out of nowhere, and they'll leave us stunned that they could've possibly happened in the first place. But this is life, man. Of course we're gonna get hit."

I smiled. "I see that. Are there any others?"

He thought for a moment. "Actually, yeah," he said. "There was another instance where I saw a boxer get the wind knocked out of him. As he lay on the floor of the ring, I remember one of the coaches standing over him. And he said to the boxer, solemnly, 'You'll feel better when that stops hurting.'"

I laughed. "That's deep."

"Right?" Patrick laughed back. "But again, it's just like any tough time we have to endure in life. Sometimes it's going to hurt. But in general, the hurt doesn't last forever. And it always feels better once it passes."

The bell sounded, and Patrick returned to his workout, this time on the heavy bag. Again, he focused, concentrating on his form, paying attention to each blow he landed. By the time the bell rang again, he was soaked in sweat and breathing heavily.

"The thing is," he continued, as if he'd never stopped talking, "I love how everything in the boxing ring counts — nothing is wasted. You waste time, you fail to concentrate, it's over. For those three minutes you have in the ring, you can't quit. But it's okay, because you know that after the three minutes, you'll have one minute where you rest. You'll get to go back to your corner and rest, and you'll be cared for by the people in your corner."

He stopped to look directly at me.

"That's why you have to be sure to have good people in your corner."

I grinned. "Do you use this wisdom when you do your sermons on Sunday?"

He became serious. "No, I don't."

I was surprised. "Really? Why not?"

"That's not what people come to church for," he said. "They come to hear the word of God, to focus on the divinity within them. And so, in the pulpit, that's what I talk about.

"However," he continued. "I do talk about boxing when I counsel people privately. Because when I'm speaking to people privately, they're usually struggling with life, with their humanity. With their mortal selves. Boxing can help frame their situations, their challenges, and much of the wisdom gained from the ring helps me to guide them through it. Besides," he grinned, "everybody loves a good boxing story."

"You really love this," I remarked, looking at him thoughtfully. "You're never going to quit boxing, are you?"

"Probably not as long as my body holds out, no," he said. "As I mentioned, I come here to pay attention to my shadow, to appease it. But I've found that it's just as important for my personal intellectual and spiritual growth, as well."

A few days later, I visited Patrick at his church. He has been a priest for nine years now and recently became the rector of a relatively large church in Houston. At work, he cuts a far different figure than he does at the gym: on this occasion he was wearing a suit, and the clerical collar had returned. Ever the host, he took me on a tour of his church, told me its history and relayed his plans for its future. Finally, we each grabbed a mug of coffee and sat down in his office.

"You know, Patrick," I said, "priests are generally the ones laypeople look to for inspiration and guidance. Who do you look to? Who do you admire?"

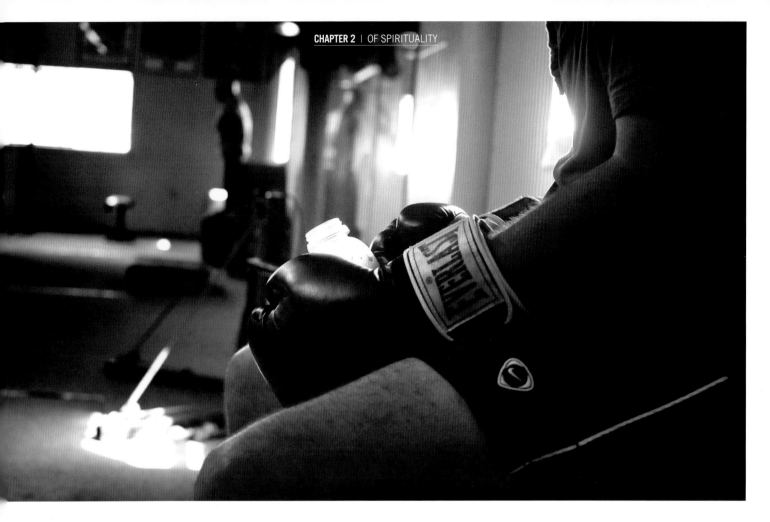

"My mom," was his very quick reply. "My mom has always paid attention to herself, paid attention to her spirit, her divinity and her humanity as well. Exercise was a huge part of her life, and she used physical exercise as a way to relieve stress, but also as a way to help her make decisions — and in many ways, I try to be like her. I mean, when I go to the gym, I pay attention to my humanity, so that afterwards, I can focus on God and my spirit before I make any difficult decision. And because of the way my mom has taken care of herself, even though she faces tough challenges in her life, she turns toward them, and not away from them."

He leaned back in his chair.

"You know, I also always remember her telling me, 'not everyone's going to like you, Patrick, but you always have to like yourself.' She was the person who taught me to be true to myself, to never try to be anything I'm not."

"So, when you're an old man, and you've lived what you consider a successful life, what will your life look like?"

He was quiet for a moment.

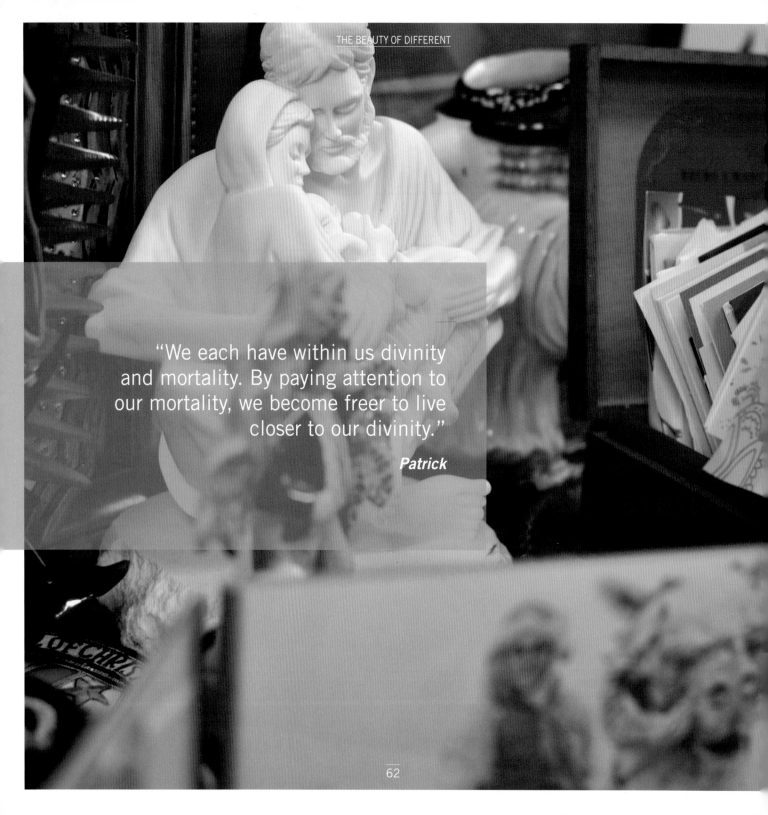

"We each have within us divinity and mortality. By paying attention to our mortality, we become freer to live closer to our divinity."

Patrick

"I hope that after I'm gone, if I've lived a successful life, my wife and my kids will be able to say I was honorable, I finished strong, that I loved and was beloved. I hope they say that every place I went, I left it better than the way I found it."

We spoke more, drinking coffee and sitting in his office, and I was struck by how much I like Patrick. There's nothing condescending about him — he is who he is, and it's clear that he's really comfortable in this fact. I love that he makes it okay for me to pay attention to my mortality in addition to focusing on my spirituality. I love that I consider him among my friends. I love that I learn from him.

So, unsurprisingly, when I left that day, I felt like a better person than I had been when he found me.

Click

I've heard that there are certain cultures in the world that believe that when a person's photo is taken, his soul is captured.

You know what? I get this.

I've noticed that sometimes, if I'm very lucky, there's a moment where the person whose portrait I'm taking feels comfortable enough to relax with me and let his guard down. When this happens, for a split second I can catch a glimpse of his spirit through my lens. It's often a bit startling, but always very exhilarating — and invariably, when it happens, the result is a fantastic image, even if the actual composition isn't all that impressive. Capturing this "photograph of the soul" isn't always a given, but when it happens, it's magical.

And so, for me, the challenge of shooting a portrait isn't about getting someone's "good side," or minimizing any physical imperfections. It's about revealing the beauty that the person has — that we all have — within our spirits.

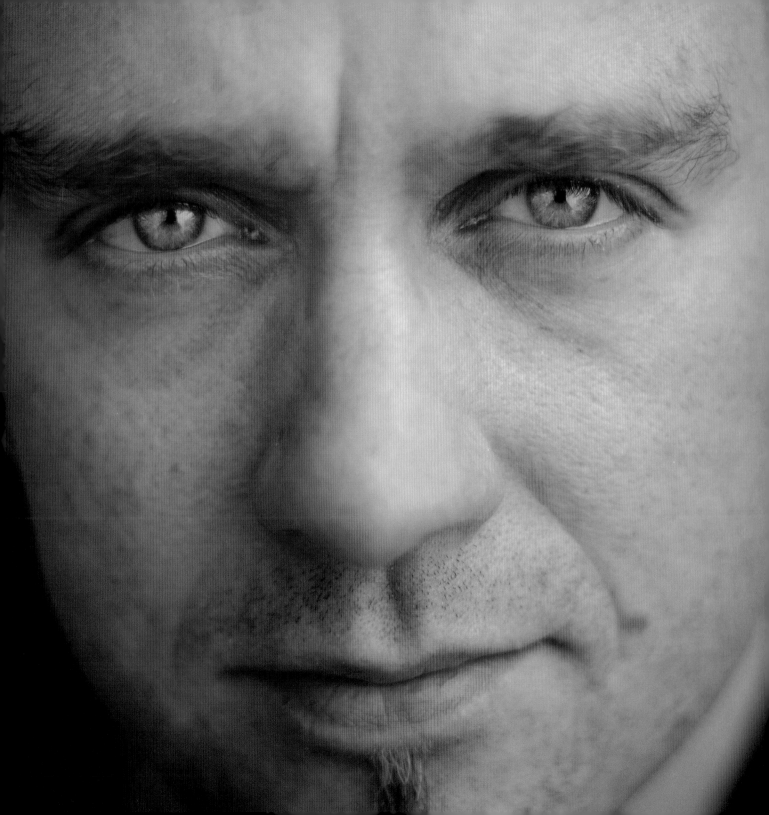

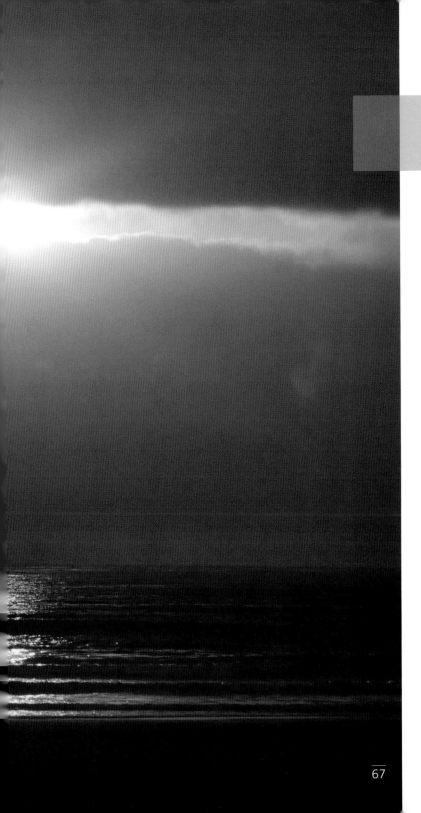

Awakening

Many people have a place they go where they feel closer and more in tune with their spirit. For some, it's a church, or a mosque, or a temple. For others, it's simply a room in their homes with a single lit candle.

While sacred places and quiet spaces work for me, the place I feel most connected with my spiritual side is anywhere near the ocean in my homeland of Trinidad, preferably around dawn. There's just something about being on a small island, listening to the sound of the kiskadees at first light, mingled with the crashing of the waves that makes me realize that we are very, very small, and the universe is very, very big.

And I can't help but wonder at the miracle of it all.

CHAPTER 3
of imperfection

"Imperfection is beauty, madness is genius and it is better to be absolutely ridiculous than absolutely boring."

Marilyn Monroe

Views
on
Imperfection

Back in the late '90s, my father informed me that he and my mother were off to live in a city called "Baku." I stared at him, convinced a hidden camera was going to appear out of nowhere and an over-eager television host would leap out of a nearby closet, point a microphone in my face and howl at my incredulous expression. "There's no such place!" the host would exclaim excitedly, "we made it up!" And then we'd all laugh and laugh.

However, it was no joke: my dad had received a job opportunity located in the capital of the Eurasian country of Azerbaijan, so off my parents went. They lived there for two years, and while residing in the recently war-torn region was at times challenging, they loved every minute of their experience there and made dear friends in the process.

When they finally moved back to the United States in 2000, I stopped by their new home to help them unpack. I was stunned when my father opened the door, and I walked smack into a wall of rolled-up woven rugs, piled high in the family room.

"Did a bit of shopping while you were there, did you?" He laughed.

"Yes. Azerbaijan is known for its rugs. It's actually an ancient center of carpet-weaving."

"Who knew?" I ran my hands along the intricate, tight knots of one of the rugs, admiring the startling colors and vibrant design of the carpet. "They're beautiful."

"They really are," he agreed. "But they're not perfect."

"What do you mean?"

"Apparently the weavers, like most weavers of the region, intentionally weave in a flaw during the process of designing and making the carpets. It's a way they acknowledge that only Allah is capable of making anything perfect."

"Hmm," I murmured, my attention returning to the large pile of carpets. "Well, they might be flawed, but they look pretty perfect to me."

Other than occasionally trying to find the flaw in my parents' carpets whenever I visit their home, I had never given this conversation much further thought until one day, I was at lunch with a friend. We were doing what girlfriends usually do: we caught up on each other's lives, discussed our families and at one point, I'm sure one of us mentioned how different our bodies are from when we were in our early twenties. "You know what, though? My concept of beauty has totally changed as I've gotten older," I said, suddenly. "I mean, have you ever noticed that sometimes at a party the woman you can't take your eyes off of isn't beautiful in the big-boobs-tiny-waist societal definition of the word? And yet there's just something about her that's just breathtaking."

"Like *wabi sabi*," my friend said.

I started to giggle. "Wabi-huh? Sounds like bad sushi."

"*Wabi sabi*," she repeated. "Haven't you heard of it? You're half-right — it *is* Japanese. It's the idea that there is beauty in imperfection. It's actually pretty common in Eastern design — it's the theory that an irregular teacup, or

one which has an aged patina, is more beautiful than a symmetrical, new teacup."

I recalled the conversation I'd had with my dad about the Azerbaijani carpets and told my friend about the concept behind the weaving.

"Sort of like that," she responded, "except it's not really about God as the only being capable of creating perfection, so much as it is that imperfection *is often* perfection."

Imperfection is often perfection.

When I returned home after lunch, I sat in front of my computer screen, lost in thought. I reached for my keyboard, intending to do a bit of research on the concept of "imperfection as perfection." The phrase seemed oxymoronic in today's society of only valuing beauty in perfection, particularly when it came to the appreciation of the female aspect. Nonetheless, I was reassured by the Google results: the concept of flawed beauty as an ideal is an old one. I learned that the Azerbaijanis weren't the only carpet weavers who included flaws in their work: Persian rug makers do the same, and sometimes Native American weavers include a flaw to "release the carpet's spirit," and "allow it to roam." I also discovered that there were many different interpretations of the phrase *wabi sabi:* "beauty that treasures the passage of time," "imperfect or irregular beauty," and even "the patina that age bestows."

Imperfect or irregular beauty. I wondered.

Beauty that treasures the passage of time.

I looked down at my own body. I thought of how many years I've spent starving it, criticizing it, wishing it was replaced by a newer, more perfect version (something like Halle Berry's would do nicely). I thought about how much it had changed over time: the lines that appeared, scars I'd earned, blemishes and defects that seemed so huge in my mind, dimples where there had been none before.

What would happen, I wondered, if we lived in a society where all of the flaws — the age spots, the wrinkles, the extra pounds — were actually viewed as badges of honor, as marks of a life well-lived? What if scars, marks or other characteristics of our bodies, the ones that make each of us imperfect, the ones childhood schoolmates made fun of, the ones we tried to hide, were instead valued and celebrated? What if we chose to see them as the source of our individuality, our power?

I think our world would be an entirely different place. I suspect drug abuse and alcoholism would go down; depression would drastically decrease. The psychology and psychotherapy industries would crumble, and the pharmaceutical industry would merely limp along. Racism, ageism and sexism would disappear and discrimination of all types would vanish. There would be no wars, no eating disorders, little crime. People would be kinder and happier. And there would be cupcakes for everyone.

Well, at least most of those things would be true.

Since that day, I find myself watching people, examining the faces of strangers — trying to do so secretly, surreptitiously — and spotting their beauty. It is surprising how easy it is to find.

Her hair, I think. *It's like strands of spun, white silk.*

His laugh lines — they make his face appear so kind.

Her beautifully lined hands. Her hands have seen the world. Her hands could tell stories.

I've discovered that when you take time to look for a person's physical beauty, without exception, it's easy to identify. It becomes obvious that everyone is *wabi sabi* — every single person is imperfectly beautiful.

It was always this way. It will always be this way.

We just have to look.

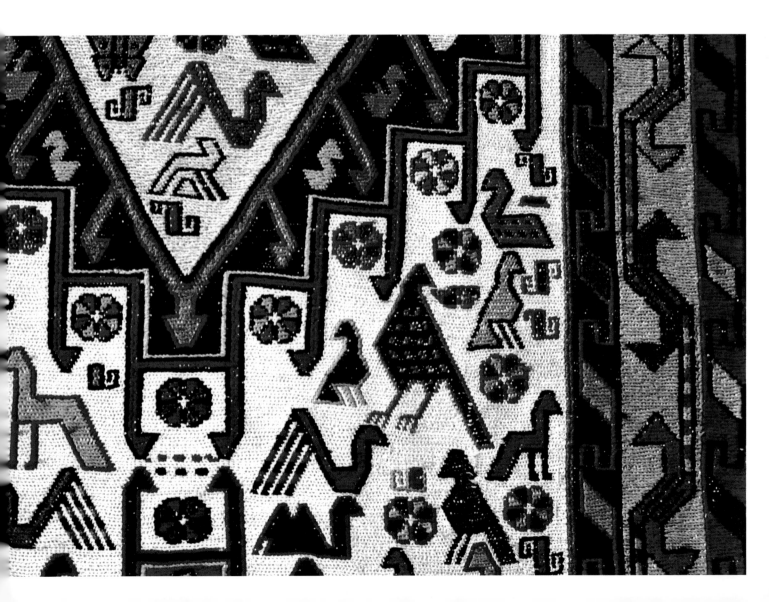

" I'm different because even though I have crooked teeth, I've never been too shy to smile. **"**

Fayza

77

" I'm different because I'm unafraid to be completely me, including the loud laughter, the bad singing, the good and the flawed. Truly and completely me. **"**

Ellie

"I'm different because I have turned **procrastination** into an **art form."**

Caleb

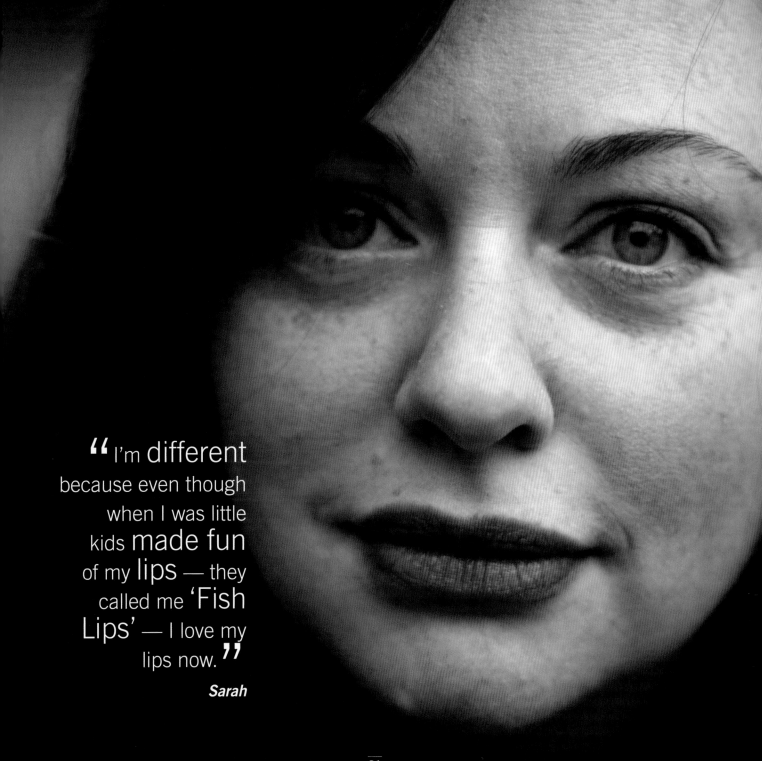

" I'm different because even though when I was little kids made fun of my lips — they called me 'Fish Lips' — I love my lips now. **"**

Sarah

A Closer Look: Laurie

I sat in the audience, one among hundreds, as the young woman with the flowing, chestnut-colored hair walked to the dais. I noticed the confidence with which she strode on stage: she seemed completely comfortable, as if giving extremely personal speeches in front of a thousand women was something she did every day. She smiled at the crowd, and began.

"I'm Laurie. The title of my essay is 'Letter to My Body, Letter to My Face.'" She spoke into the microphone in a strong, clear, self-assured voice. *She's so calm, so sure of herself,* I thought. *This woman is a force to be reckoned with. I can tell.*

"My face has worked overtime from that random genetic moment in the womb — about four weeks in, so I understand — where she didn't fully fuse, leaving me shooting out into the world with a split lip and palate, to her daily grind since then."

Wait, what?

I scanned her face — we all did — and the energy in the room changed on hearing these words. My eyes finally rested on the small, telltale scar above her lip and below her nose. *Oh. But you can barely see it. I don't understand why this would be an issue.*

But as I listened to Laurie continue to speak in her strong, soft way, I learned that her small scar *was* an issue. She told us stories of insensitive nurses telling her mother on the day baby Laurie was born how unfortunately they viewed her physical situation. She related university experiences at bars where men approached her, not to ask her out, but

rather in the hope she'd help set them up with her beautiful roommate. But what was striking, however, was the way she told these stories: even as she recounted the cringe-worthy behavior of the people with whom she'd come in contact over the years, her voice never wavered, never waned. It was very difficult to imagine the woman reading the stirring words she'd written could have ever been a victim of anything, much less the cruel barbs of insensitive louts.

I continued listening to Laurie, mesmerized, as was the rest of the crowd sitting with me. As she neared the end of her speech, she took a deep breath. And then she looked directly at the audience:

"And always, always, completely on purpose, I will wear fabulous lipstick."

There was thunderous applause, drowning out thank-yous as she left the stage. Several listeners stood to their feet and wiped emotional tears from their cheeks. For that single moment in time, we all understood, if only for a little bit. We all empathized. And we absolutely cheered her on.

Later that same evening, at a party, I made my way through the crowd toward her.

"I'm Karen," I introduced myself. "You were wonderful today. And that was one of the bravest things I've ever seen."

"Thank you," she said breathlessly, her eyes sparkling, still on a high from the many accolades and compliments she had been receiving since that afternoon. "It was amazing. The whole experience was amazing."

She was amazing. She was *beautiful.*

In the months that followed, I often thought of Laurie and her speech. Almost a year later at another conference, I was able to actually sit and speak with her in a more personal setting than a crowded party. On that day, I was running late and came rushing toward her where she was standing in the hotel lobby. She was easy to spot: her confidence and pose were immediately recognizable.

Her striking, couldn't-miss-it-if-you-tried green dress made her an easy mark, as well.

"Great dress," I said, as we hugged our hellos.

"Thanks," she smiled. "Green is my power color."

We searched for a quiet corner in the bustling hotel lobby so we could talk. We finally came across an empty bar, clearly closed, but we walked in anyway. A lone bartender, cleaning up from the previous evening's crowd, looked up with dismay.

"Oh, we don't want anything!" I said quickly. "We were just hoping for a quiet place to talk."

He smiled and nodded slightly before returning to his work. There were a couple of seats nearby, so we settled in. We made small talk, discussing the amazing weather in Chicago, having both escaped the heat of more southern locations on this trip. Laurie and I were both contributing writers for the same publishing company, so we gossiped and chatted about people we'd met through the organization. Although this was really our first time having a face-to-face conversation, Laurie is a warm person, and I immediately felt like we'd been friends for years.

Our conversation turned to the subject of her speech a year earlier.

"I so loved listening to you that day," I said.

"Thanks," she replied. "It was very freeing to write."

"I bet it was," I said. Then I asked gently: "How old were you when you had your first surgery?"

"I was six weeks old," she answered. "There are actually no photographs of me prior to that age."

"Really? So you don't know what you looked like when you were born?"

"No, no idea. But you have to understand: it was a different time. Pictures just weren't taken of children who were cleft-affected. In some countries, it's still considered the mark of the devil, so the fact that no pictures were taken prior to constructive surgery, at that time, in this country, well — that's pretty mild."

"Does it bother you that no pictures were taken?"

Laurie paused, her face darkening slightly. "Yes, I suppose. I mean, it would be nice to know what I looked like as a newborn, you know?" But then, she immediately brightened. "But my mom — she's so wonderful. She always tells me, 'You have always been beautiful to me. Always.'"

"Sounds like you were close."

"We were. We *are*. I'm close to her, and I was very close to my grandmother. She died this year." Laurie became quieter. "My grandmother's death was the deepest loss of my life so far." And then she looked at me: "But yes, we're a very close family."

Laurie paused, thinking.

"My family never made me feel I was unattractive. *Ever*. In fact, at one point in recent years, I was put in touch with a woman who was in the process of adopting three children who were cleft-affected, and she was telling me that she was worried about how her extended family would deal with the issue. I immediately told her that it was imperative that her children never feel that she thought they were unattractive. Her family home needs to be their haven. My family was always my haven. Still is."

"Do you remember the first time anyone ever said anything to you that made you feel less than beautiful?"

She frowned. "I remember when I was about ten years old, a little boy — who was none too attractive himself, now that I think about it — said something awful and cruel to me."

"What did he say?" I asked cautiously.

"Oh, something like it looked like my face was run over by a truck."

"Good Lord, Laurie. How did you respond?"

"Oh, I'm sure I cried," Laurie said, smiling softly. "And I told my mom. Of course, my mom said the right Mom Things. But thankfully I was never encouraged to dwell when things like this happened to me."

It can be so horrifying being a kid, can't it? As I listened to Laurie speak about her childhood, I remembered a few things I was told by childhood friends — negative comments about my appearance, my clothing, my hair, my race — that are still vivid to this day. Worse, I internalized these sentiments well into my twenties and thirties. I don't remember the day when it finally dawned on me that by continuing to consider these horrid comments over time, I was, in effect, allowing the taunts of children to affect me as an adult — which, when considered in

that light, seemed ridiculous. I do know that day felt like Emancipation Day, on so many levels. I wondered how Laurie managed to process these experiences.

I asked, "So did the comments eventually stop, as you grew older, and out of elementary school?"

She laughed. "Oh, *definitely* not. I mean, college was brutal. I actually didn't really start dating until I was about twenty-three years old. I just never considered myself a viable option, you know? And even after university, it continued. In fact, within the last few years, I had a coworker ask me out-of-the-blue when I was 'going to get more work done.'"

I shook my head incredulously.

"I know, right?" Laurie smiled. "It's pretty unbelievable what some people will say. I mean, I might think someone looks a hot mess, but their clothes would have to actually *be on fire* before I would say something about their appearance."

I started to laugh.

"Seriously, though!" she continued, laughing with me. "It's shocking what comes out of the mouths of some folks. I had one particular boyfriend — we'd actually been dating for some time — who felt moved to confess to me that at first, he didn't think he could date me. He was an artist, and so was used to drawing symmetrical faces. He said he didn't think he would've been able to date me at first because I'm asymmetrical."

"Good Lord. What did you say to him?"

She grinned.

"I think I said something like, 'Well, honey, I'm not so sure I would've picked you out of a lineup, either.'"

I snorted. "Dude," I said, "I'm so impressed with how quickly, how confidently you're able to respond. I think I want to grow up to be you."

"Well, I have to admit: having a sense of humor about it all has probably saved my life."

"I imagine having a sense of humor would clearly *help*," I said. "But surely even your wit had to be tested dealing with comments like these. How do you manage to keep it all from getting to you?"

She thought for a moment.

"Well, okay, so yes, laughing about it all helps," she said slowly. "But you know what really changed my life? What really gave me good perspective on the concept of beauty?"

I shook my head, waiting.

"Photography."

"Really?"

"Absolutely. In 2005, I went to photography school, and on the first day, my instructor said, 'Photography is the most important anthropological record of modern time.' That stuck with me. I remember learning how to develop film, and the first time I dipped the paper into the chemicals and an image emerged, I exclaimed, 'It's like magic!' And the instructor smiled and said, 'That's what I wanted to hear. Exactly.' And it is like magic.

"So a few years after I began studying photography, I had the opportunity to visit Hanoi, Vietnam, for a

ten-day program on online journalism. I was scared, but I had to go, and I was so glad I did. It expanded my worldview.

"While I was there, Operation Smile — a children's charity of doctors and other medical professionals who treat cleft lips and cleft palates — was on a dental mission, so I grabbed my camera and went to see the work

they were doing. It was amazing. I had always taken my own health-care for granted. My experience in Hanoi made me realize that I shouldn't."

She took a deep breath.

"Anyway, yes, photography has changed me. Photography got me out into the street, got me outside of myself. I'm not afraid to travel anywhere and everywhere, because of photography. I hope one day I can finally go back to Vietnam. In fact, I want to go everywhere!"

"So, over time," she continued, "I've learned that my creative work — finding my voice, both in writing and in photography — and having people respond to it positively has been critical in my learning about whole beauty. Eventually, I even began taking self-portraits. Some may call it vanity, but I think it's the opposite. I mean, if you

have trouble getting your picture taken and dealing with visual representations of yourself (which I have, all my life), taking self-portraits is a way at first to control that experience and become more comfortable in front of a camera lens. For me, it was a huge step towards becoming comfortable with having someone else point a camera at me; even now, it's still not my first love, or even my fiftieth, but at least I can handle it more gracefully than before."

"I think I get it," I said. "So taking self-portraits helped you, ironically, to get out of yourself, to see yourself as a photographer would? It helped you find your own beauty, from an objective perspective?"

"Right," she nodded. "I've found taking my own picture to be really freeing. Or maybe it's just because when the world tells you — explicitly or implicitly — that you ought not to be vain, that you, in fact, have very little

to be vain about, it's a way of discovering that, hell yeah, maybe you do. Because sometimes," she grinned, "I decide I look sort of cute in those self-portraits. That feels good."

"Good!" I said, laughing. "Because you are!" Then, more seriously: "And dating? That's improved since college, I'm guessing?"

She laughed. "You know, I tell people that I go out on dates, and each date lasts for five years. I've been in a series of long-term relationships — some really good ones, and some very serious ones. Over time I've learned that people who zeroed in on my flaws aren't really people I want to be around, or even be friends with, much less marry, anyway.

"Of course I've had bad breakups, and there are times, like everyone I suppose, in between relationships when I feel like no one will ever love me. Although, I remember once confiding in someone during a particularly bad breakup: she listened to me talk and complain about how I would never be loved again, and after a while of this, I remember her looking me dead in the eye …" — at this point, Laurie looked at me directly — "… and she said, very slowly, *'But you realize, of course, you have data to suggest that's not true.'*"

"Wow," I breathed. "That's pretty damned brilliant."

"Isn't it?" she agreed.

We sat thinking about this statement, watching the clouds outside the huge picture windows float by. And then, I asked "So, when did you finally figure out that you are, in fact, beautiful?"

Laurie laughed out loud. "Oh, I don't know that I've figured *that* out, quite yet," she admitted. "But you know what? I'm getting there. Things are so different for me now. I feel like I'm in a really good space right now, learning to be much more positive. Some of it is just growing up, I guess. When I was a child, I was always grateful for any type of friendship, in whatever form it came. But since then, I realize that I deserve more. I've been through 'relationship detox' in recent years, surrounding myself with people who inspire me, who are good for me."

I thought about this for a minute, and I had to agree: so much of finding self-worth is about really becoming clear on what you value and the characteristics you celebrate within yourself — and then, ensuring that the people with whom you connect, the ones you call friends, are people who reflect these characteristics back to you. "Relationship detox," it seemed to me, was a good exercise to engage in every now and then.

Laurie continued: "In the past, my self-image had so much to do with what I allowed people to tell me about myself. I think we can create our own stories about ourselves, you know?"

"That's interesting," I agreed, "but I think creating our own stories about ourselves isn't as easy as it sounds. How do you do it?"

"First, I think it's important to have a haven. For me, it's definitely my family. But if you don't have a haven, it's important to create one. I once had a friend who felt she didn't have a haven with her family, so she decided instead to create a haven in her home — make her home a place where her friends and other people who were important to her would seek out to find refuge. Eventually, of course, the friendships that continued to be forged in her home became her refuge. Creating a haven is difficult, but it can be done.

"And second, I think it's important to tap into your own creative work to help create your own story. Writing, of course, or journaling, is a great way to do it, but so is photography. For example, the self-portraits that I take: it's all about writing my own story. Because you can write your story visually, too."

Her brow furrowed.

"I just decided that I wanted to take charge of what I do, who I do it with and where I do it, rather than allowing other people to control those things. And writing and photography help me record it all, help me tell my story. I don't let people tell me about myself anymore. I'm much more focused on creating my own story than letting other people create it for me."

"And your story is that you're beautiful."

She looked at me for a moment, her eyes twinkling, her brown hair shining in the sunlight streaming in from the window. And then she grinned.

"Absolutely."

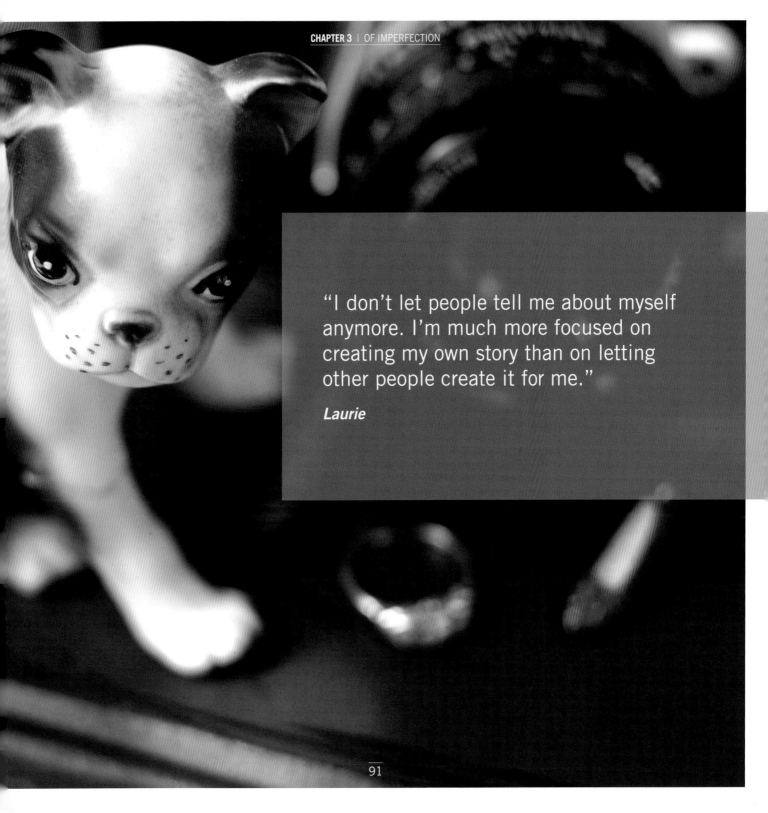

"I don't let people tell me about myself anymore. I'm much more focused on creating my own story than on letting other people create it for me."

Laurie

Imperfect Perfection

About fifteen years ago, I was friends with a young woman, Kimberly, who was undeniably beautiful: she was tall and thin and had perfect porcelain skin. She was a designer by trade; because of her creative eye, she was also incredibly stylish, always wearing the perfect clothes and the perfect makeup. She was the girl that all men wanted to be with and all women wanted to be.

Surprisingly, however, she wasn't a particularly happy person — she was constantly dissatisfied with the way she looked or the amount of money she made or any of a variety of other aspects of her life. Though she was always impeccably put-together, she was slightly uncomfortable with the fact that her clothes weren't associated with any tony name brands. And even though she was thin by every definition of the word, she constantly believed she could stand to lose a few extra pounds.

I remember the first time she invited me into her home. She lived in a tiny, one-room studio apartment. Knowing Kimberly as I knew her, I remember walking in expecting a well-appointed, minimally-yet-perfectly decorated space. I think I may have even held my breath as I stepped inside.

I was somewhat shocked by what I discovered. It was a beautiful space, yes, but it was completely devoid of any identifiable trend or style. The décor was hardly minimal; in fact, everywhere you looked there was eye candy to attract your interest. She had adorned her walls with graphically beautiful posters — some of them garage sale finds, some of them museum discards. The space was filled with second-hand furniture that she had either refurbished or left in a perfect aged patina. The bookshelves were filled with design books she'd collected, and in addition to the lamplight that illuminated the room, she had lit dozens of candles and had hung strings of twinkle-lights around her apartment, lending a positively magical air. I gasped.

"Kimberly," I sighed as she poured me a glass of wine, "your home is beautiful."

She looked around the room, her face glowing. I'd never seen her so relaxed. "It is, isn't it?" she said. "I can't help myself, I love my little home. This place is just so me."

I remember thinking then, and for years afterward, that it was uncanny that she was so easily able to find the imperfect beauty in her own home and all the quirky items in it, and yet was incapable of seeing how stunning she herself was, imperfections and all. In truth, however, we are all the same: we find it easy to spot beauty in the most imperfect objects but can't see our own imperfect perfection, illuminated by our own souls.

Twenty Imperfections

that most practical people agree are
just perfect (as indicated in the results of a
perfectly imperfect survey)

1. Dimples
2. A clover with four leaves
3. Unusual birthmarks
4. Laugh lines
5. A scar with an interesting story associated with it
6. Strong noses
7. Art made by children
8. Gap-toothed smiles
9. An unusual laugh
10. Crow's feet
11. White hair (premature or otherwise)
12. A distinctive mole
13. A crooked smile
14. A stubborn cowlick
15. Inadvertently snorting while laughing
16. The Leaning Tower of Pisa
17. Ancient ruins
18. A slightly raspy voice
19. Eyes that squint when smiling
20. Freckles

CHAPTER 4

of anxiety

"I've been absolutely terrified every moment of my life — and I've never let it keep me from doing a single thing I wanted to do."

Georgia O'Keeffe

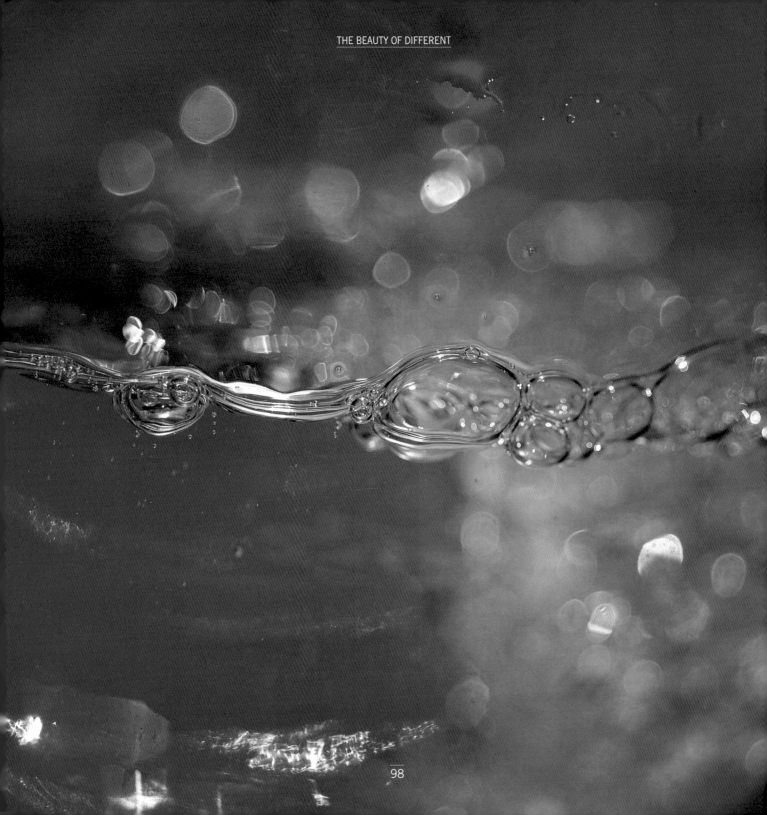

Views on Anxiety

By nature, I am a complete coward. Flying insects — regardless of ferocity — make my heart race. The mere thought of driving faster than sixty-five miles an hour makes me somewhat faint. I've been known to burst into tears on roller coasters. *Kiddie* roller coasters.

And yet? I love to scuba dive.

How I came to be a certified scuba diver really makes no sense. I'm not a very strong swimmer, and like most people who have studiously avoided learning to dive, I'm not particularly fond of the thought of shark encounters. But when I was thirty-two years old, I suddenly thought to myself, *Self, you love the water. You're from the Caribbean, for God's sake, the site of some of the most popular diving in the world, and you've barely visited any islands other than your homeland. Have you no shame? Get certified, woman.* So I conned a coworker into taking a certification class with me at a local dive shop's swimming pool, and six weeks later, I was a diver.

Soon after I was certified, I began to get excited about the prospect of returning to the Cayman Islands, a beautiful place I'd visited in the past. On my previous trip, I had spent every morning looking longingly at the dive

boats making their way out to sea. Now that I had my dive card, I knew it was time. My coworker/codiver wasn't going to be able to make the trip with me, so for the first time in my life, I planned a vacation alone. I researched dive operations on the island, bought a ton of trashy novels for my solitary time above the ocean's surface and booked my tickets for four days in paradise. While Cayman Islands is possibly one of the safest countries in the world and I was staying in an apartment with all the amenities I could possibly desire, I felt intrepid. Courageous. *Damned brave.*

Brave, that is, until my first morning on the island, when the van from the dive operation came to pick me up at my rented apartment.

I climbed into the vehicle, filled with calm-looking tourists. The divemaster for our tour was also the driver of the van, and he treated me to a cheery "good morning!" and a stack of legal waivers and disclaimers to sign while on the way to the boat dock. I began reading the language, written to ensure that I understood that the dive operation wasn't liable for any injuries arising out of all the possible dangers of diving, including shark attacks, fire coral, getting the bends, nitrogen narcosis, jellyfish stings, barracuda, giant squid, rogue stingrays, the occasional mean-spirited sea slug …

"… you a lawyer?" my thoughts were interrupted, as a sense of doom began to settle around me.

"Um … yeah," I said.

The divemaster laughed. "I can always tell. No one actually reads those contracts except for lawyers. You can go ahead and sign them. You'll be fine."

Easy for him to say. Here I was, reading about all the possible things that could go wrong on this trip, this trip I'd foolishly decided to go on by myself, this trip which was undoubtedly going to end in some lone fisherman finding my mangled, chewed-upon body weeks later, this trip which would require the authorities to obtain my dental records to identify me, and I hadn't been to a dentist in over a year.

I signed the paperwork.

Sadly, my mood continued to deteriorate. We all climbed aboard the boat and motored out to the dive site. As we sailed on, the divemaster pulled out a large whiteboard and began to draw a map of the topography we were likely to see. "We'll descend to about 100 feet here," he began, "and you'll see lots of coral, lots of tropical fish, some tarpon — a large silver fish that looks like a barracuda but is totally harmless. But, you know, you may also see barracuda. And perhaps a shark or two."

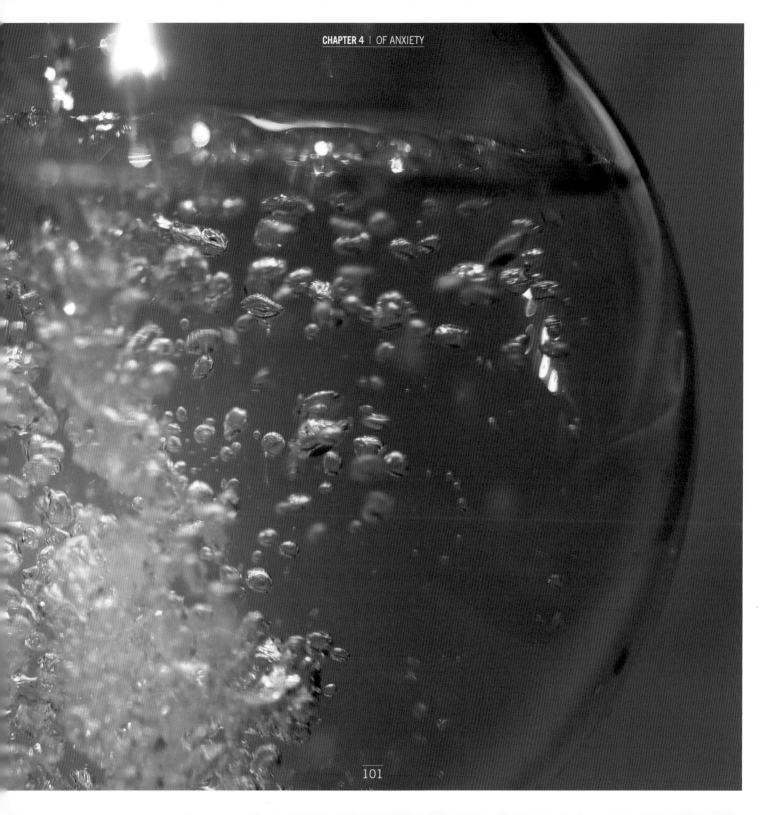

Gulp.

"Then," he continued, "we'll make our way south, where we'll arrive at the drop-off. They estimate that the ocean floor at that depth is about 25,000 feet, so be sure to keep your eye on your depth gauge, and stay around 100 feet — you don't want to descend too far into the blue."

Sweet mother of Gumby.

The boat engine stopped, and everyone began putting on their tanks and fins. Since there were only couples on board, all of the divers naturally buddied up with their partners. The divemaster looked at me. "You'll partner with me," he said.

"Thanks," I replied shakily. Then I made my way closer to him.

"You should know, this is only my third dive. Also? I have a really hard time with my ears, equalizing ear pressure when I descend — it can take me some time."

He looked concerned.

"How deep have you been before?"

"About sixty feet, I think …"

"You're going to be fine. One hundred feet doesn't feel any different than sixty feet. We'll take it slowly, and just stay close." He smiled, his voice was gentle.

I nodded. He helped me into my tank, I affixed the mask securely to my face, and put the regulator in my mouth. One by one, we all entered the water, and I was the last to take my giant step into the amazingly aqua ocean.

The divemaster swam to me: *Are you okay?* he pointed and motioned in diver sign language.

I'm okay, I motioned back.

Good, he indicated. *Let's descend.*

Slowly, I began to let the air about my buoyancy compensator, the vest that divers wear to regulate both their descent and their floatability. I looked down — below me, I could see the other divers waiting for us on the ocean floor. *Breathe slowly,* I told myself. *It's meditation. Breathe slowly.*

The diver master stayed with me, looking into my eyes. Slowly, we descended, and without warning, my feet

suddenly touched the sandy bottom. I checked my depth gauge. Ninety-eight feet.

Are you okay? the divemaster signaled again.

Relieved, I grinned, the regulator still my mouth. *I'm okay,* I signaled back.

Suddenly, I noticed movement to my left. I looked, and a huge sea turtle swam by, looking at us with a bored expression. Before I could have time to marvel, a spotted eagle ray soared above us, silently undulating its wings in the still, brilliant blue water. I was completely overcome with wonder, forgetting my earlier apprehension.

Let's go this way, the divemaster signaled to the group.

We all followed, swimming about three feet above the ocean floor. There really wasn't much to see — some rocks, rather unimpressive coral, the occasional fish. Rather quickly, however, the rocks and coral began to become more plentiful, until we were swimming single file through what appeared to be a narrow trench. Because the water was so clear, even at this depth, the ocean around us was bright blue, completely lit by the sun above.

I checked my depth. One hundred feet.

Unexpectantly, a current picked up, and I could feel it propelling me quickly forward. I kept my eyes on the sandy bottom, wondering what was happening, but suddenly, before I could panic …

… *the ocean floor completely disappeared.*

The drop-off.

I turned around, to see where I'd just come from — I was now facing a wall, the underwater cliff from which I'd just soared, and I was hovering about 10 feet away, in what felt like mid-air.

I was floating free.

I was flying.

I looked down, trying to make out where the ocean floor finally began again, but it was no use — it was too far down. All I could see was a deep indigo blue of nothingness.

I checked my depth gauge. One hundred five feet.

The divemaster appeared out of nowhere. *Are you okay?*

I screamed with unbridled glee, sending a spray of bubbles from my regulator. "YES!" I shouted, motioning wildly. "I AM SO OKAY!"

The dive ended pretty quickly after that. When you're at that depth, you can't stay down at the bottom for very long. And while I've been on many dives since that one in Cayman, some of them far more beautiful and teeming with sea life, I've never, ever forgotten the feeling I experienced on that dive. I remember being overwhelmed with joy … and *pride*. I'm not a brave person, but there I was, on vacation by myself, over one hundred feet below the ocean's surface, *flying*. It is a memory I come back to anytime I feel nervous, to remind myself that I can do … or at least, *try* … anything.

Even if I still do run away from cockroaches.

" I'm different because I work myself to death. I've always excelled at everything, so now I'm afraid of failure. **"**

Will

" I'm different because lost and scared children and animals always find me. "
Debbie

" I'm **different** because I **finally** figured out I'm really **good** at **accepting** and **embracing** change. "

Michelle

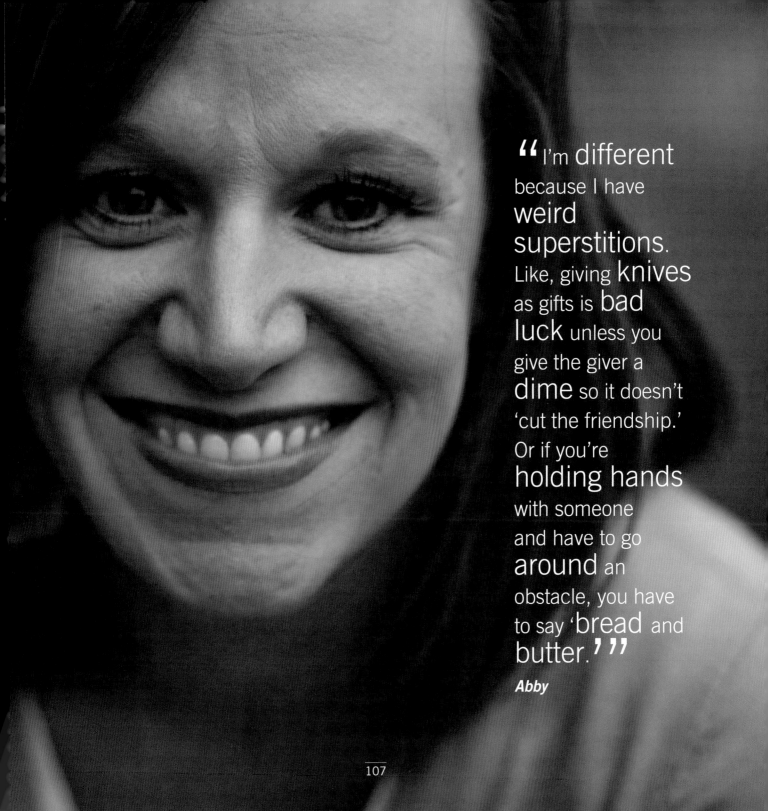

"I'm different because I have **weird superstitions.** Like, giving **knives** as gifts is **bad luck** unless you give the giver a **dime** so it doesn't 'cut the friendship.' Or if you're **holding hands** with someone and have to go **around** an obstacle, you have to say '**bread** and **butter**.**"**

Abby

A Closer Look: Jenny

"I'm going to be sharing a hotel room with Jenny," said my friend Laura, a few years ago. "Do you know her?"

"No," I responded. "Should I?"

"I don't know, maybe," Laura said. "She writes a blog for the *Houston Chronicle*. I thought perhaps you might have come across her. Anyway, she's painfully shy, and she's really nervous about going to this convention. So I'm going, and I promised that I would share a room with her."

"Oh, wow, bless her," I responded. "Well, have fun."

During the twelve months that followed, I finally met Jenny. I watched her stand on a table in a crowded bar, leading a large group of writers in their very first networking meeting together. I began reading and quickly became a fan of her personal site, *The Bloggess,* where she talked about everything — *everything* — with considerable abandon and even more profanity, to hilarious effect. I even saw her give a speech in front of about one thousand people, wearing a decidedly weird blonde wig, as the audience wept in appreciative and admiring laughter.

Jenny? Shy? Surely Laura had been talking about a different person.

"Nope, same Jenny," said Laura, when I brought it up one evening some time later, while Jenny, Laura and I were having dinner at a restaurant. "She is shy! Aren't you shy?" she continued, turning to face Jenny.

"Oh, I'm shy," Jenny nodded emphatically, looking at me straight in my eyes. "I'm really, really shy. I've been incapacitated before."

I looked at her skeptically. "I don't believe you," I said, levelly.

Eventually I got to know Jenny even better. I discovered that when she publicly announced to her guests that if they wanted to see her at the huge party she was hosting, they would have to visit her in the bathroom where she was hiding, this wasn't just gimmicky schtick, it was honesty — she really

did need to remain hidden in the bathroom in order to function. That weird blonde wig, which I later learned she called her "Confidence Wig"? It turns out it was absolutely necessary for her to wear it in order to have the courage to get on stage in front of one thousand strangers. And although the photo shoot for this book entailed her wearing a 1940s-style swimsuit, while a mutual friend painted words on her body was admittedly anxiety-inducing, Jenny was required to steel her courage in a way most of us wouldn't have to. What's interesting, however, is that Jenny-Off-the-Computer, who deals privately with anxieties and phobias every single day, is just as authentic as Jenny's online, outrageous persona, "The Bloggess," with her hilarious profanity and razor sharp wit. Bridging the two sides of her personality is her incredible capacity for kindness, boundless consideration and caring. Jenny couldn't be mean-spirited if she tried.

Jenny and I live on opposite sides of town, so when we get together, we often meet somewhere between our homes. Over time, we've settled on one particular spot: it's quirky, with bright orange walls, huge murals of old-time pin-up girls, and some of the best egg breakfasts in Texas. It has become almost tradition for us to meet every six weeks or so, just to catch up on each other's lives. On one particular occasion, our conversation became pretty intense. We discussed some personal aspects of our past, and she allowed me to ask her about her anxiety. "Is this something you've always dealt with?" I gently asked. "Or is it recent?"

"It's my earliest memory," she said.

"Really? Tell me."

"I remember I was about four years old. My mom took me to the Bookmobile — you know what that is, yes? One of those mobile libraries? So anyway, I was there, and we ran into another little girl who was going to be in my kindergarten class. I remember my mom trying to get me to be friendly to her, since we were going to be in the same class, and I was petrified. I couldn't speak to her. All I could think was, 'I'm going to throw up in front of her. I'm going to throw up, and she's going to tell everyone in school that I threw up on her.'"

"Wow. And you still feel like this all the time?"

"Pretty much. Social anxiety disorder has affected most of my family. I have an aunt who recently died, and she spent the last part of her life in and out of hospitals because of it. I just remember watching how fragile she was. At first, when she was younger, she would socialize with the family, but eventually she got to the point where she would hide — usually in the bathroom — even when it was just me over at her house, visiting her daughter. I mean, think about it: she got to the point that she couldn't even come out and see her niece." Jenny smiled wryly. "In a way, she sort of taught me that the bathroom is the best place to hide."

I thought of the several times I had found Jenny hiding in the bathroom during parties, and smiled. "Okay, so you remember feeling like this since you were four — and you spent your entire childhood feeling like this?"

"Yup. I was the only goth girl in the whole school. I mean, sure, there was a part of me that liked the whole goth look, but the truth was I knew that if I dressed all in black and sat in a corner reading *Jane Eyre,* everyone would just dismiss me, say, 'Oh, that's just Jenny,' and leave me alone. It was a defense mechanism. I was petrified. I didn't speak."

"You didn't have anyone in your childhood that you could confide in?" I asked.

She smiled. "One," she said. "Ms. Atkins. She was an art teacher, in seventh grade. She was just like me, but way more of a dingbat, completely, eccentrically dizzy. She was the first person I'd ever met who was like me. She'd traveled all over the world — I loved that. I'd go to her house, and we'd make this amazing art. She was the first person who made me feel like it was okay to be eccentric."

Jenny was quiet for a moment.

"Anyway," she finally continued. "I also remember always being ill — that's my big indicator, I get ill when I get nervous or am about to panic, I feel nauseous, I get hives — and it was many years before my mom realized that all the illnesses, during major holidays or any time I was stressed, weren't just coincidences."

In that small breakfast café, over eggs and French toast, I sat there, transfixed, as she told me stories of times when she panicked, or, when things were really bad, instances when she seriously thought about taking her own life. She told me about times in her life when she experienced incredible loss, including one particularly painful miscarriage that almost sent her completely over the edge. Eventually, I interrupted.

"So, Jenny, what changed? I mean, it sounds like you spent most of your life afraid, you hardly spoke, you were in a downward spiral and life was dealing you a hell of a time. What pulled you out of it?"

"Well, I remember watching my aunt — the one who recently died — and I realized that her hiding made her more and more fragile. If I continued to 'stay in the bathroom,' so to speak, I'd end up becoming more and more fragile myself."

"Fragile? What do you mean by 'fragile'?"

"It's like you live all your life in the bottom of the ocean, and eventually you just don't have the strength to come out."

"But you did," I countered. "You could've totally stayed at the bottom of the ocean, but you didn't. What made you come up for air?"

"Well," she said, "two things happened."

The first, she says, was the end of an unhealthy relationship. The person with whom she was involved was incredibly controlling, to the point where she had falsely convinced herself that being reclusive and separating herself from people around her was actually a manifestation of her loyalty to him. Eventually this person betrayed her, and she began to realize that her anxieties had been exploited.

"And the second thing that happened?"

"Blogging, actually," she responded. "By the time I started blogging, I had already sought professional help and was receiving counseling and treatment on a regular basis. But even so, the changes in me over the last three years that I've been blogging have been dramatic. I used to be quiet, very passive, but through blogging, I was able to find people who experienced the same sorts of anxieties that I experience. It was the first time that I began to realize that the things that made me different, the things that I'd always wanted to hide are, in fact, the things that make me special."

I thought about this and was immediately transported to a time in childhood when I was feeling particularly "different." I had recently moved from my home country of Trinidad to Houston, and I was attending a school where I was one of the few minority students, and possibly the only one with a foreign accent. I remember confiding in an adult friend, a teacher, who tried to comfort me by telling me my difference "made me special." When I heard those words, I didn't believe her — in my adolescent mind, I assumed she was confusing the meanings of "special" and "freakish." Yet these many years later, the truth in my teacher's encouragement has become clear. Sometimes it takes reframing the thing that makes us different and realizing that the trick is to understand that our differences aren't impediments but a call to use them in a way that brings more to the table. Our differences can be sources of power, of peacemaking and of inspiration. And now, listening to Jenny, watching the

earnestness in her manner and the light in her eyes, it was clear that Jenny understood this concept. She not only saw her Different, but celebrated it. She truly believed the concept that her Different was special.

Suddenly, Jenny became energized.

"I used to describe myself as 'crazy' all the time, and my mother hated it. Then once, a couple of years ago, I wrote a post on my blog where I came clean about my mental illness. And in this post, I said that I was okay with crazy. Crazy wasn't necessarily a bad thing. I was okay with admitting that I was crazy. And then …"

She began digging through her handbag and eventually pulled out a small fragment of yellowed paper.

"This is one of the comments that a reader left me on that post. I've carried it around with me since that day. She told me that she had emailed my post to her daughter — I remember she called her daughter her 'golden girl' — because her daughter was going through her own anxieties and difficult time. And she told me how much my words helped her daughter."

At this point, Jenny looked at me, a glimmer of amazement in her eyes.

"I began to realize that the parts of me that are broken can help other people, too."

I thought of all the people who had responded so powerfully to her writing. "Yes, they can." Then I continued, "but you know what, Jenny? I'd never describe you as crazy. I mean, yes, there's no doubt you're eccentric, but I can't think of you as crazy. I think of 'crazy' as being out of control. You're always in control."

Her brow furrowed as she considered my words. "Yes," she said, "even when I'm out of control, I'm sort of in control. I mean, I know when it's going to happen — when the panic is coming. And I usually say to myself, 'Well, okay, here it comes, I'm just going to go along for the ride, and watch what happens.'"

"You detach?"

"Yes. I detach," she said. "It's been a great way to cope. And besides, I think I have the gift of perspective — it's why I am able to surround myself with good people, family and good friends — who take care of me. And I can sort of step out of myself and look at how I'm feeling from outside, and I can see what people see. I can look at myself and go, 'dude, that's fucked up,' in sort of a detached manner. And then, luckily, I'm able to write about it in a funny way."

I pushed on.

"Okay, Jenny, fair enough, but you do some pretty daring things, even for someone who doesn't have social anxiety disorder. I mean, you've given speeches in front of huge crowds. You've thrown really big parties with other people. And last year — what, you flew in a jet onto a Naval aircraft carrier, for heaven's sake! How the hell do you get to the point where you can do that?"

"I'm always thinking, every single second of my day, *how can I escape*. So for example, with that party, I hid in the bathroom, because that would narrow down the number of people that I would have to deal with at one time — and if that became overwhelming, I could just walk out of the bathroom. Once I know that I have a way to escape, then it becomes easier for me to cope."

"Right. But in the case of the aircraft carrier thing, when you're on a jet …"

"… and I'm afraid of flying …"

"… over water …"

"… and I can't swim …"

"… and you're about to land on an aircraft carrier …"

"… and I'm afraid of giant squid …"

"… where there are thousands of strangers, military personnel on board waiting to greet you, what exactly was your escape plan, then?!"

She smiled.

"Oh, then? When I have to face things like that, that's where the Confidence Wig comes in. That's when I become someone else."

"Ah," I said, trying to understand. "So … you … become someone more confident?"

"Yes," she explained. "It's not multiple personality disorder or anything — I mean, I'm still me. But I pretend to be someone else. Someone more confident. The wig helps — I don't need the wig all the time, of course — but regardless, I detach and make believe I'm someone else. Someone who can handle the situation. And it usually works. Of course, the Xanax helps as well," she added with a grin.

"That's amazing, Jenny," I said, shaking my head in wonder. "You could easily just choose not to do those things, particularly since you know how crippling your anxiety can be. It's so courageous."

"Maybe," she said, " I don't know. I think courage is sometimes just about choosing between the emotionally safe thing and the stupid, try-to-push-yourself thing. And stupid is always more fun." She laughed.

I laughed as well. Suddenly, I noticed that the breakfast crowd that had surrounded us when we arrived had disappeared. The waiters were preparing for the lunch crowd, a signal it was time for us to leave. We gathered our things, but as I was about to stand up, Jenny stopped me.

"Wait," she said. "You're a diver. Can I tell you a story about something that happened to me while I was snorkeling?"

I love when something suddenly comes to her mind right out of the blue like that. I sat back down. "Sure," I said.

"I was in the Yucatan — I was about thirty years old. Victor and I were married, but Hailey wasn't born yet. Now, you know I'm terrified of water and I can't swim, but for some reason, Victor thinks it's a good idea for us to go snorkeling in a *cenote,* which is like this underground cave filled with water. So we hire a tour guide and rent some wet suits (because the water in these caves is freezing, and it's so pure that you can't wear sunscreen or anything), and we get into this Jeep that looks like it's about to fall apart.

"So then we're standing in the back of this Jeep — because there were no seats — and we start racing through the Mexican rainforest, like right through it, in the middle of the jungle, with monkeys jumping around and everything. And I'm thinking *oh my God, we're going to die … Monkey! … We're going to die … Monkey! … We're going to die …*

that

GHTER is beautiful, he

KINDNESS is

interesting. to

adventurous

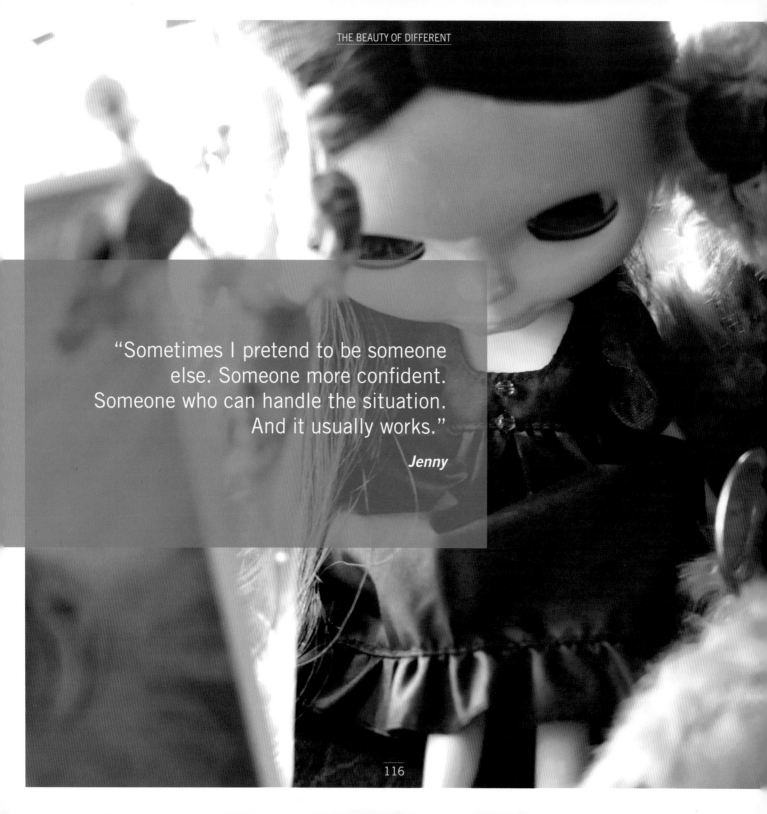

"Sometimes I pretend to be someone
else. Someone more confident.
Someone who can handle the situation.
And it usually works."

Jenny

"And finally we arrive, and I don't see anything but jungle, and I think *this is where we get mugged,* and then I notice the guide is pointing to a huge hole in the ground with a rusted ladder. I couldn't see the bottom, but I figure *what the hell* and I climbed down anyway.

"So we get down the ladder, and suddenly we're in the middle of this amazing underground ocean, with the purest, bluest water ever, and the water is freezing. I have the mask on, and Victor is telling me 'Put your face in,' but I'm too scared and I start to hyperventilate, and the guide starts to look worried.

"But then, finally, even though I'm terrified, I put my face in, and the water was completely clear, and I could see these huge — HUGE — what are they called? Stalagmites? Stalagmites, just jutting out of the ocean floor. It was amazing. And that's when I suddenly realized that below the surface was this entire whole world, and I would've never seen it if I hadn't been brave enough to put my face in."

I smiled, taking in her story and feeling very lucky that I do know Jenny and count her among my friends. Because after listening to her for the past few hours, it dawned on me that with all her neuroses and phobias, detachments and Confidence Wigs, it appears Jenny has actually figured out the Meaning of Life:

You just have to put your face in.

Eight Things
I'm Afraid of, but Other People Probably Aren't

1. Feet. Particularly other people's feet.
2. Clowns. They're horrifying.
3. Squirrels. They're not cute. They're rats with fluffy tails.
4. Looking over the sides of things: precipices, buildings, my bed …
5. Kazoos. Okay, they don't really frighten me so much. But they definitely unnerve me.
6. The little rodent-like thing that is sitting next to Jabba the Hutt in *Return of the Jedi*. That thing haunts my dreams.
7. Geese. One tried to attack my Volkswagen once. And it came close to winning.
8. Manhole covers and grates on city streets. Because, of course, they are portals to the bowels of Hell.

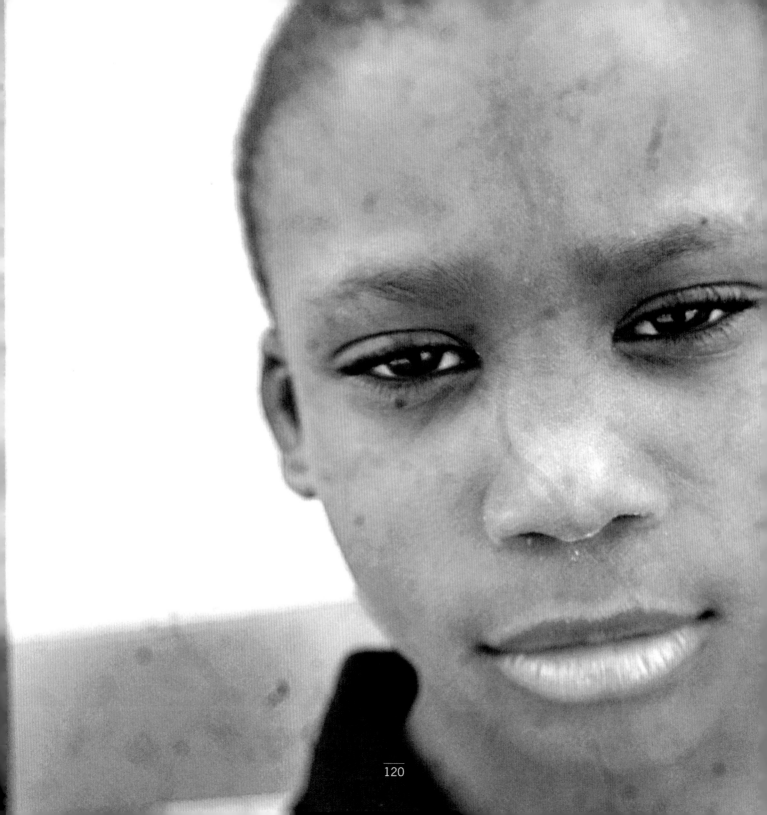

Clarity

The biggest act of bravery I've ever witnessed, it has nothing to do with astronauts blasting into space or firefighters running into a burning building. It's that image of the lone man standing in front of the huge military tank bearing down on him in Tiananmen Square during the protests of 1989 — do you remember this? I remember sitting in front of the television watching that scene unfold and wondering to myself if I would ever possibly have the courage to stand against such military might. I'd like to think I would, but honestly, I don't know.

But as I ponder further, I think that perhaps the key to courage is being certain — I mean, *absolutely clear* — on who you are and what you stand for. That the first step in being courageous is being absolutely comfortable in your own skin.

And that maybe the courageous act that you're called on to do may not actually feel courageous. Maybe, instead, it will just feel like the only possible thing you could do.

of heartbreak

"All the world is full of suffering.
It is also full of overcoming."

Helen Keller

Views On Heartbreak

At the risk of completely jinxing myself by uttering these words, I have lived an inordinately lucky life. I have remained relatively healthy for the most part — no broken bones, no major surgeries. I've had no one really close to me die, save for my grandmother, and at the time she was 102, so despite my initial (and somewhat unreasonable) shock, her passing wasn't entirely unexpected. Of course, as with every life, there have been disappointments in mine — goals not attained, relationships that haven't worked out — but in general and in hindsight, there's no event that I can think of in my past that I would call an instance of true, profound heartbreak. As a result, I had become convinced that there wasn't any unfortunate circumstance that I wouldn't be able to overcome.

This conviction weakened considerably when my daughter Alex was born. Something visceral happened when I became a parent: along with the love came this

instinctive, animal-like drive to protect my child at whatever cost. And the consequences of failing to do so … well, they're really too horrible to think about.

My first realization of this fact came when my daughter was about two years old. My family and I had returned to my homeland of Trinidad: my husband, Marcus, had quite serendipitously received a job opportunity there, and since much of my extended family remains in Trinidad, we leapt at the chance to return. Soon after we picked out a home, and our furniture and all our belongings arrived, we settled into a simple life. Marcus would go off to his job working with people he enjoyed and respected, we found a wonderful Montessori daycare and preschool that Alex adored, and I spent my days at home alone, writing to my heart's content.

As it happens, Trinidad lies along a geologic fault line; so experiencing small tremors isn't uncommon. When the first few happened, Marcus and I would regard them with a certain measure of amusement. "Can you feel that?" we'd say to each other. "Um … no … wait, yes!" was the common response. We'd sit silently for a moment and marvel at what was happening.

One particularly beautiful, sunny morning, however, after I had dropped Alex off at her preschool and Marcus had been at work for several hours, I sat in front of my computer in time to feel a small tell-tale tremble. I stopped typing. *Is that an earthquake?* I thought to myself. *Oh wow, I think it is!* I waited for it to stop, and for a second, it felt like it was waning. I turned my attention toward my computer screen.

And then, things became much worse.

The ground began shaking violently, and cupboard doors started opening and slamming shut. A picture suddenly went askew on the wall before crashing to the floor. The computer screen went black, as all electrical power suddenly ceased. I leapt from my chair and ran outside and away from the building, trembling, while the ground continued to jolt unrelentingly. *Oh God, please don't let anything happen,* I remember praying. *Please.*

As the shaking abated a bit, my cell phone began ringing inside. I hesitated, knowing that it was likely Marcus, knowing he would be

worried if I didn't answer. The shaking wasn't nearly as intense as it had been seconds earlier, so I raced in to grab the phone and ran back outside.

"Hello?" I answered tentatively. The ground still shook.

"It's still going! It's still going!" I heard Marcus speaking to someone in his office, his voice faint and tight with fear. Suddenly, he seemed to remember that he'd called me, and I heard his full voice as he turned his attention to the receiver. "Hello? Karen? Are you okay?"

"I'm okay," I said, my voice breaking.

"It's still going," he said.

"I know."

And then a few seconds later, everything stopped moving.

"Are you okay?" Marcus asked again.

"Yes, I'm fine," I said. "A picture fell off the wall. But I'm okay."

"That was something, wasn't it?" he said, laughing weakly. "That was crazy!"

"I know," I said. "Alex must be freaking out."

There was a small commotion in the background. "I have to go," he said abruptly. They're evacuating the building. I have to go."

"Okay, I'll call Alex's school," I said. He hung up.

Before I could dial the number to Alex's school, the phone rang again. It was Alex's school director, sounding very unnerved. "Karen?" she said, "we're closing the school. We have no power, and the children are scared. Can you come pick Alex up?"

"Of course. I'm on my way."

I immediately grabbed my keys and jumped in the car. While I was driving, I couldn't stop thinking about the earthquake, or trying to imagine what might have happened if there had been serious damage. Her school was about five miles from home — not far, by any stretch — but if it had been a devastating earthquake, it might have taken a lifetime to get to her. When I arrived, Alex was still frightened. "Mummy, the walls!" she said excitedly. "The walls!"

"I know, baby," I said, strapping her into her car seat. "It's over now."

Later that day, after the power had returned, there was an aftershock — not nearly as strong as the first quake, but it didn't matter, we were still on edge. As soon as the tremors started, I ran to Alex, grabbed her out of her

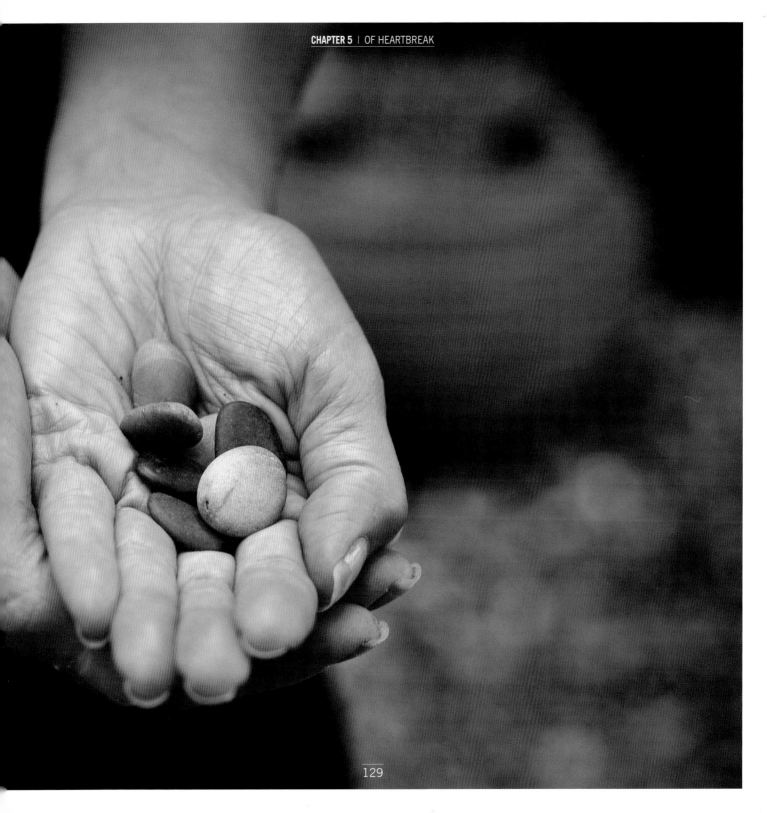

highchair and ran outside. By the time we made it outdoors, the quake had stopped.

"Mummy, the walls!" she said again.

"I know, sweetie," I said, kissing her, still shaking myself. "It's okay. It's over." But still, I couldn't help thinking about what would've happened if it *wasn't* over. What would've happened if there had been catastrophic results? The thought of losing Marcus and Alex — in an *instant* — was too horrible to consider. What would I do? How would I continue with my own life?

That night we learned that the earthquake had measured approximately 6.2 on the Richter scale. There was no widespread damage, and while there was one injury, there were no deaths. Despite the movement in our own home, nothing really valuable broke, and the only reminder of the day's events was a suspicious crack that had suddenly appeared in our bedroom wall. In the grand scheme of things, this earthquake was minor, an insignificant occurrence. It was nothing.

Years later, after we'd moved from Trinidad back to the United States, a devastating earthquake hit Haiti, another Caribbean island, decimating its capital, Port-au-Prince. As I watched the images on *CNN* of people trapped in the rubble, frightened children calling for their parents, distraught parents screaming for their children, my memories of the earthquake back in Trinidad came flooding back. *It can all change in an instant,* I thought. *How would I make it if something awful happened to my family? How are these Haitian families going to make it?*

But here's the thing: in the days after the Haitian earthquake, as news of aid, heroic feats and acts of bravery and unmitigated generosity started rolling in, I was reminded that whenever something horrifying happens — a natural disaster, an act of terrorism, the diagnosis of a potentially fatal disease — one of the beautiful by-products of these heartbreaking events is the way that people, strangers and friends alike, really rally together to help one another. No matter what nasty, horrifying curve ball life decides to throw at us, as crippling as the circumstances may seem, we are never alone. There is always someone willing to help, to offer support, to lend a hand. If only we are willing to rely on each other, it is possible to emerge stronger on the other side, ready to pay it forward if we are able.

I'm reminded of a video that my cousin once sent me. It was taken at a "going away party" of an acquaintance of his: this person wasn't moving anywhere, but was imminently dying of cancer. In the video, this man had stepped to the microphone to speak to the huge gathering of friends and family who had come to celebrate his life. After he had thanked everyone for coming and assured them that he felt particularly blessed to have the opportunity to tell each of them how much he loved them before he passed on, he said the following beautiful words:

"Just because we have this profoundly sad thing — the end of a life in our lives — doesn't mean that all the other things that bless our lives are no longer present. They're just all the sweeter for it."

Amen. Because the truth is, despite the trials we *all* face, there is always some good in *all* our lives. We just need to remember to look.

"I'm **different** because I know the pain of **losing** an unborn **child** but I've also found my **inner** strength."

Kristen

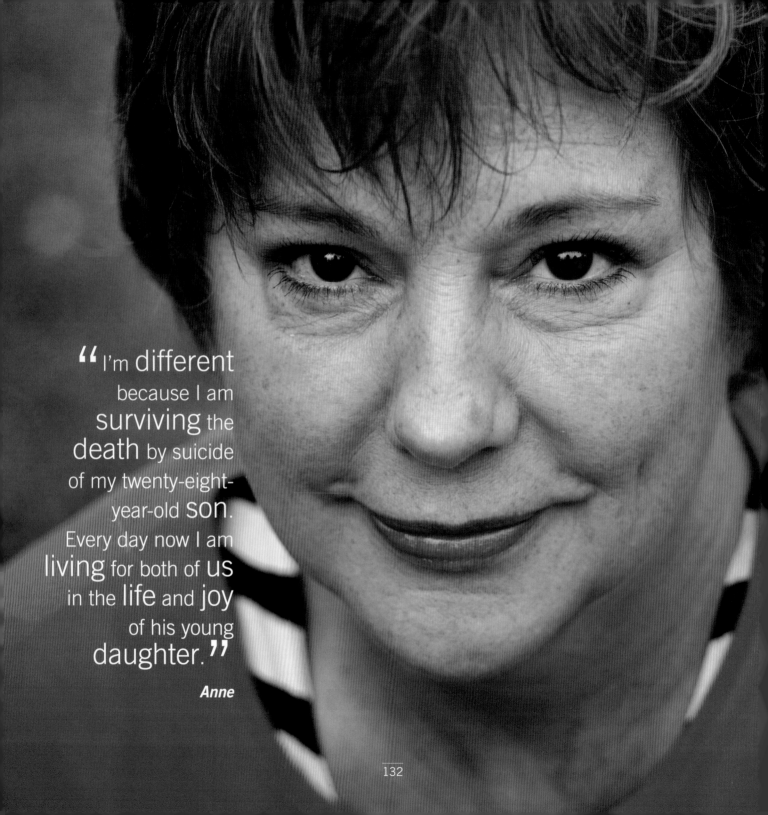

"I'm **different** because I am **surviving** the **death** by suicide of my twenty-eight-year-old **son**. Every day now I am **living** for both of **us** in the **life** and **joy** of his young **daughter**."

Anne

❝ I'm **different** because I have a **guardian** angel. My **son**, Joseph, came into this **world** when I was only twenty-three weeks **pregnant**, but it was too soon, and he couldn't **stay** long. I feel **comforted** knowing he is **looking over** my husband and me. ❞

Melissa

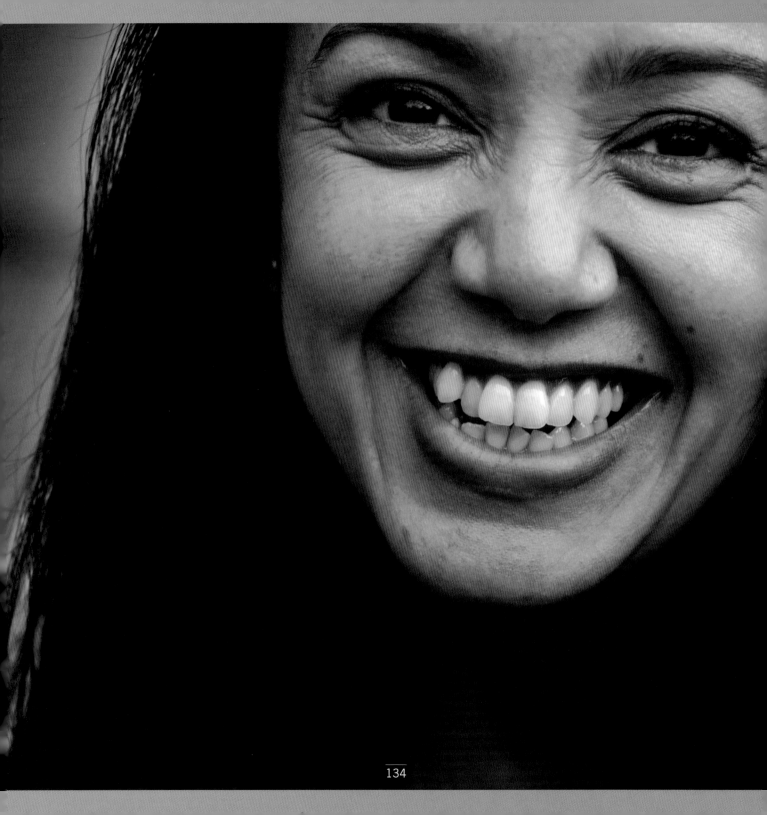

" I'm different because after having lived a turbulent life, one which included lots of chaos and uncertainty, I've managed to rise above it all and find a reason to smile. I am a survivor. **"**

Samhita

135

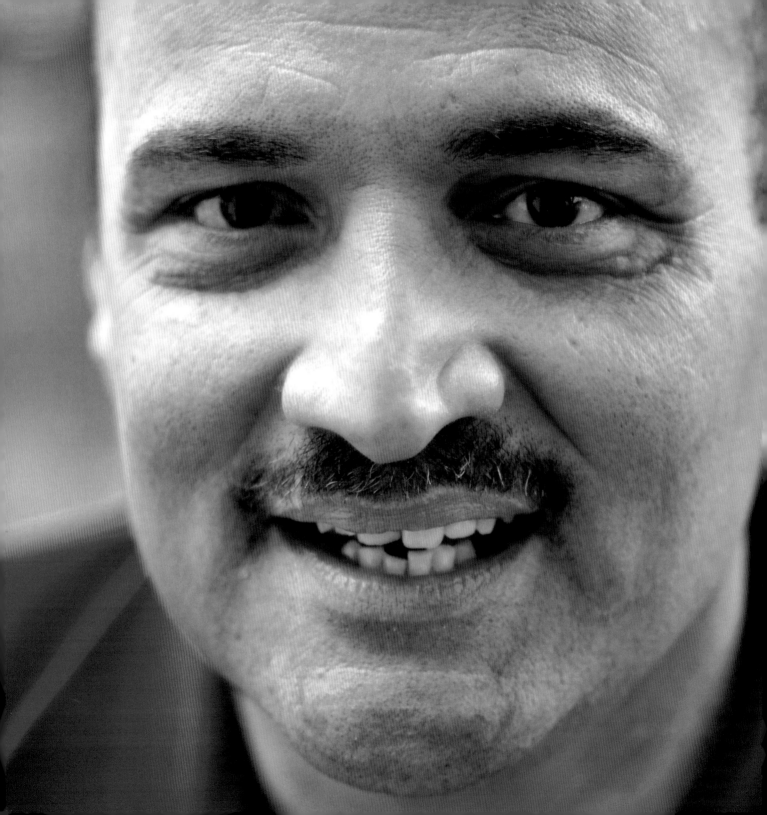

A Closer Look: Allen

Under normal circumstances, we might not have met, Allen and I. But one day, I was talking to the chief executive officer of a not-for-profit I'm involved with, and I was telling her about the extraordinarily beautiful people I had recently been meeting and photographing. "Oh," she immediately insisted, "you have to meet Allen. He works for us, and his story is amazing. Promise me you'll talk to him. *Promise.*" And so I gave her my word.

This is how I found myself sitting in a café attached to a large, organic supermarket — I'd arrived early to enjoy a cappuccino and to make the day's to-do list in my journal — when a tall, burly, good-looking man walked up to me.

"Are you Karen?" His eyes sparkled and his smile was warm as he extended his hand toward me. I stood and took it; he clasped my hand in both of his.

"I am!" I said, returning his kind gaze. "Please, sit," gesturing to the remaining café chair.

"It's so nice to finally meet you," I began, as we both got comfortable in our seats. "Kelly speaks highly of you."

"Oh, I adore Kelly," he said. "She's been such a wonderful supporter of mine. I'd do anything for her."

"Well, I'm thrilled you agreed to share your story with me. She tells me it's an amazing one."

"I'm happy to share it."

"So, tell me everything! You're from Texas, right?"

"Born in Galveston," he smiled. "I'm half-Mexican, half-white. The story goes that my dad was in the military, and he was hitchhiking from New Orleans to Missouri. One day, he stopped at the Mexican restaurant where my mom was working, and he thought my mom was so beautiful, he paid one of the other waitresses to introduce him to her. He says he knew that very day that he was going to marry her, and sure enough. Eventually they had my three brothers, my sister and me."

"Did you have a happy childhood?"

"Not exactly — it was pretty traumatic. My dad was an alcoholic," Allen answered, matter-of-factly. "I remember I was twelve when I started being his bartender. 'Fix me a drink, boy, and make it a double!'"

The memory brought a wistful, half-smile to his face.

"That must have been tough."

He nodded. "It wasn't easy. In fact, that's when I started sneaking drinks for myself as well."

"Oh," I said. And then, hesitantly: "I'm sorry, I don't think I understand — and excuse me for asking such a blunt question, but — you saw your dad drinking and saw what it was doing to him and you started drinking, as well?"

"I know. On one hand, it doesn't seem to make any sense, does it?" he admitted. "But back then I thought that alcohol was a really great way to escape. So I started sneaking drinks, and I started smoking cigarettes, which eventually led to marijuana. And then, I became a total juvenile delinquent. I was finally thrown out of school at age sixteen."

"'Finally'? What was the last straw?"

"I was drunk at school, and I hit a kid," he said, rolling his eyes. "My parents finally had enough, so they shipped me off to live with extended family in Oklahoma."

As Allen was speaking, I grew more and more surprised at his story. The man sitting before me wasn't anyone I would've ever suspected has having a tumultuous life or a violent past. He was soft-spoken, with kind eyes and a quick smile. *That's some metamorphosis,* I thought to myself.

"Did you end up straightening up after you moved to Oklahoma?"

"Nah. It didn't take long to figure out who the bad kids were and where the drugs were. In fact, there was this one girl, Snaky-Poo …"

"I'm sorry, did you just say Snaky-Poo?"

Allen laughed. "Yes. She was this really beautiful girl, and she and I became friends. We'd get drunk together, smoke together, getting in and out of trouble … you know, as I think of it, I'm not sure I remember her real name, but we always called her 'Snaky-Poo.'"

"Did you … and Snaky-Poo … end up getting thrown out of school in Oklahoma as well?"

"No, this time I actually managed to graduate. I finished in 1981 and moved back to Texas — Santa Fe, you know where that is? And then I got a job as a butcher."

"You're kidding. A butcher? Why a butcher?"

"The opportunity just presented itself. So I became a butcher at a local supermarket. It was a good job, and I was good at it. But I kept using — sometimes at work — and also, on the side, I started dealing."

"Oh, God." The thought of Allen using those huge blades while he had been high was terrifying.

"Yeah, it wasn't good," he said grimly. "The worst was that during this time I was borrowing my mother's car, and eventually the cops showed up at my parents' house. Unknown to me, the car had been under surveillance. Thank goodness the police knew my dad and knew that my mom couldn't possibly have been dealing.

But it was still a big mess. I'd been on the delayed entry program to join the Navy, so I was really relieved when it all blew over and I was able to enlist."

"I bet! Kelly mentioned you'd been in the military. Tell me about the Navy."

"I loved it. I started boot camp — thirteen weeks — and it was the best time of my life. I got clean, I was in great shape. I went to school and became a machinist. Then after boot camp, I was stationed in Hawaii."

"Awesome."

"You're not kidding. I was on a fast frigate — there were 360 men on board. And spending all this time on the ship, with all the men, that's when I started becoming confident that I was gay."

"Wow. Had there been no signs before?"

"Oh, of course, I had had some experiences before," he said frankly. "And I had incredible shame about them, as well. You see, you just weren't gay in my family. It just wasn't acceptable. So I kept it all a secret. It was awful."

I couldn't even imagine. Though my own life was nothing like Allen's, I thought about things I'd hidden from my own family over the years — artistic interests that I didn't believe my analytically inclined family would understand — and how I always suspected that my dreams of living a more creative life would be dismissed as impractical and therefore never have been taken seriously. The result was a dull, nagging feeling at the back of my mind as I followed a career path in more analytical, logical fields — jobs that, while I was capable of doing them, never felt fully authentic. If simply choosing to do a job different from what I wanted to do could cause me discomfort, I can't imagine what it must have felt like for Allen to choose to *be* someone other than who he authentically was.

"What happened?" I asked.

"Well, I made this one friend, Tim. He was also in the Navy, and he was straight. We used to hang out together all the time — going to bars, getting drunk, flirting with women. Over time, however, I began to realize I was falling in love with him."

"Did you tell him?"

"I did."

"Oh. My. So … how did that go over?"

"Not well," Allen said grimly. "He kept telling me not to say those things. And he tried to ignore me. Well, back then, I was still prone to beatin' up folks, so when he didn't listen to me and he didn't understand, naturally I beat him up. It landed me in the mental-health ward of the base. I told the psychiatrist everything and was diagnosed as 'depressed, with homosexual tendencies.' I was in for ten days."

He smiled wryly at the memory. "I remember at one point, I was lying in bed with headphones on, listening to, of all things, Barry Manilow. This older nurse walked up to me and said, 'Child, you are depressed. Stop listening to that depressing music.'"

He laughed.

"So what happened when you got out?"

"I did it again."

"Wait … you beat Tim up again?"

"Yup. I tried to talk with him about it again, and he couldn't deal with it again, so obviously I beat him up again. And landed right back in the mental-health ward." He shook his head. "This time they decided perhaps it was best for the Navy and me to part ways. They offered me an honorable discharge but required that I give up all my benefits."

"An honorable discharge?" I was confused. "But I thought …"

"Well, because I'd never been caught engaging in any homosexual activity, they didn't dishonorably discharge me. I happily accepted their offer. I'll never say anything bad about the military — they always knew exactly what was going on with me, and through it all, my peers and my superiors were never anything but kind to me.

"So anyway, while I was waiting for my discharge papers, I was moved to desk duty. It was during this time that I met Mark. He wasn't in the Navy — he was a professional ballet dancer, and he was so great. He was my first love, my first real relationship. Since I hadn't actually been discharged yet, we had to keep our relationship secret — so I started telling friends and family that I was dating 'Marlene.' I was particularly worried about what my John Wayne like father would say, so I kept it secret. Once my discharge papers finally came through, I moved in with Mark. I remember I told my family, 'Marlene and I broke up, and she moved out, so I'm staying with her roommate, Mark.' It was the easiest way for me to start transitioning to the truth. And eventually I came out to my friends and family."

"How did that go?"

"Surprisingly well. At one point, since I was still living in Hawaii, I came back to Texas to visit my family. And I remember one evening, my dad grabbed me by the shoulders and said, 'Allen, I do not agree with your lifestyle. But you are my son. And you will always be my son.' That was the beginning of the healing of our relationship."

As Allen spoke, I saw relief wash across his face at the memory, and I smiled in recognition. In my experience, nothing is more freeing than being as authentic as possible with the people who love you — and realizing that they love you all the more as a result of it.

Then he continued, his expression darkening.

"Anyway, about two months into dating Mark, I noticed that he was acting strangely, that something was wrong. When I pushed him to tell me, he said, 'I tested positive. You should go get tested, too.' I immediately went to get tested and discovered I was positive as well. I was devastated — remember, back then, in the '80s, an HIV-positive diagnosis was a death sentence. I ended up confiding in a mutual friend, and I remember him shaking his head. 'God, I knew this would happen one day,' he said, 'ever since we found out two years ago that Mark was positive.'"

"Wait …"

"Yeah …" Allen interrupted, watching me process what I just heard.

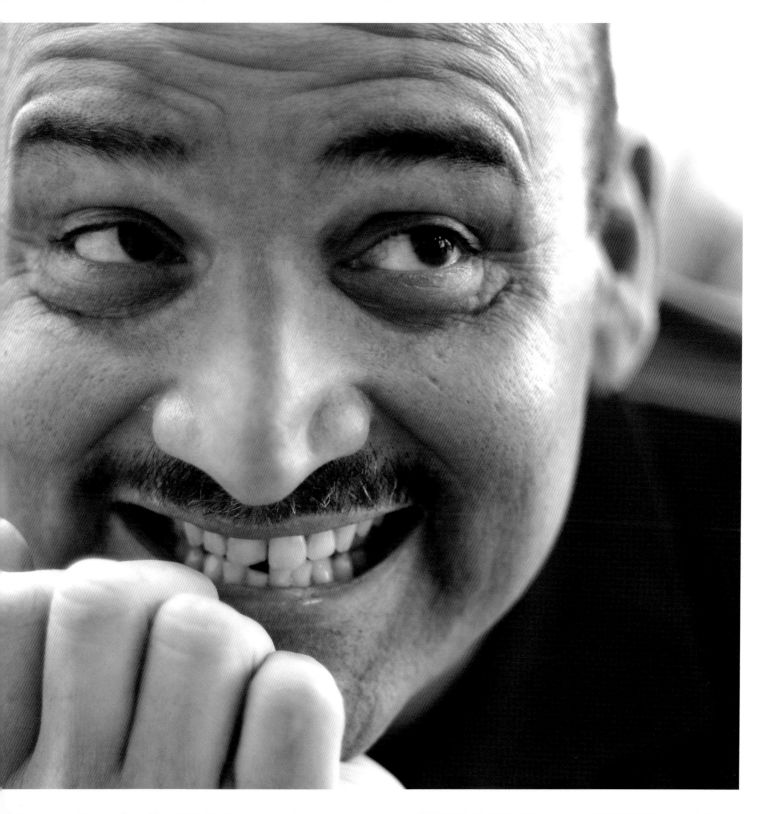

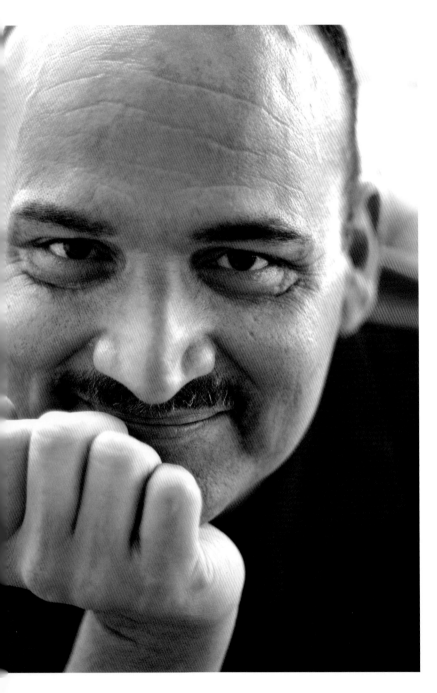

"So wait, Mark *knew* he was positive, and he never told you, and gave you HIV?"

"Yeah."

"Dude, I'd kill him! You must have been livid!"

"Oh, I was," he said. "I raged for quite some time. But then, eventually, I calmed down. Back then, we were all struggling with this new disease, this AIDS thing. Ultimately I understood that Mark really loved me and was dealing with the diagnosis and how to tell me the truth the best way he could. So I came back, and I took care of him. For two years. I was with him until the end."

"When was that?"

"January 7, 1990. He died at home. I loved him. He was the person who made it okay for me to be who I was."

Allen paused for a moment, lost in the memory of that day.

"Anyway," he resumed abruptly, "after he died, I was still in Hawaii, so I found a job as a butcher again. And then I became the worst drug addict I have ever been. I was doing marijuana and alcohol, of course, but also cocaine. I spiraled completely out of control."

That's the thing about heartbreak — it can convince you that not only have you lost control, but that you will never have any control again. It convinces you that there's no hope, there's no point trying to live anymore. It can be so hard to make yourself take even one step out of the hopelessness. Given what Allen had endured, I was amazed he was able to do it.

"So what happened?"

"Well, one morning, I woke up, and my pillow was soaked with blood — the result of a cocaine bender. The sight of that pillow was enough to convince me that I couldn't keep living like this. I kept thinking about something my mom always used to say: *stand your ass up and walk forward.* So I finally did. My friend Carey convinced me to call a suicide hotline, and eventually Alcoholics Anonymous. I finally attended my first meeting.

"I've been sober for coming up on twenty years now," he added proudly.

"That's amazing, Allen. Good for you."

"Thanks. It was hard work, but eventually I kept getting better and better. Then one day I saw an ad in the paper for a substance-abuse counselor for people with HIV. Even though I'd never had any counseling experience, I figured my life experience gave me something to contribute, so I applied anyway. I got the job. It was so great. The people I worked with and the people I helped were all so great."

"It sounds like life was going really well for you, Allen. You'd clearly completely turned things around. Why did you come back to Texas?"

"Well, my father got cancer. Our relationship had increasingly improved over time. We had sobriety in common by that point — my father had started going to AA — so that helped as well. I knew it was time to go back. I moved back to Houston and began working at the Gulf Coast Center for the Mentally Challenged. And then, on my off time, I spent time with my father and helped him convalesce. By this point, I'd watched so many of my friends die of AIDS — really close friends — I had become very comfortable with death and being around people who were dying. I came back home, and by the end, my father and I were very close — I know I was the closest family member to him. When his time came, I was with him. At the end of the day, my father was the biggest character in my life. I loved him very much, and I'm so glad I was with him in the end."

"You know, Allen, as I listen to you talk, I'm sort of stunned with your capacity to forgive, and to make peace with some really tough stuff in your life, particularly given your moments of deep anger and sadness. It's amazing, really. How do you do it?"

"Well, see, Karen, the thing is," he began, "after everything I've been through, when it's my time to leave the Earth, I want to know that there isn't any unfinished business. I've come to believe that love is the most important thing in life — and if that's my guidepost, then I have to forgive, I can't hang on to anger anymore, or hate. Now, even if people have a hard time with me, or how I live, I can't be angry or hateful. I just embrace those who embrace me, and I pray for the rest."

"That's pretty big of you," I said.

"You think so?" he wondered. "I don't know — I've just realized it's easier for me to forgive and love. Being angry and hateful just takes so much effort," he smiled.

"But what about your life now?" I pressed. "You're HIV positive … or has it progressed to AIDS?"

"Oh, yes, I have full-blown AIDS now."

"So, how does this not make you angry? Don't you have any regrets about this at all?"

"Well, obviously, there's nothing cool about HIV or AIDS," he began slowly, "but you know what? HIV

and AIDS put me on a path of caring. It led to my eventual sobriety. And it teaches me to live every moment, because life is too precious to waste. In a lot of ways, HIV and AIDS are the reason I'm living a good, happy life now."

I sat there in that supermarket café, looking at Allen's kind face, his warm eyes and his smile. I realized, with a certain amount of shock, that being in Allen's presence, even after hearing about all the hardship and heartbreak he'd experienced in his life, the emotion I was feeling was one of great peace. His capacity for reconciliation of the difficulties he'd faced in his life was inspiring. As someone with a tendency to worry and fret when things aren't going my way, it was a lesson for me to consider a new way of approaching heartbreak. Perhaps times of hardship shouldn't be viewed as crippling events, but rather as an opportunity to live as my best self, to live my best life. In some ways, the idea seemed ridiculous. Yet, in others, it seems like the only logical way to make it through — to accept the circumstances with peace, and resolve to carry on in strength.

Allen interrupted my thoughts.

"You see, Karen," he continued, "the way I see it is that yes, I could've done without the pain in my life. But you know what?

"If that had happened, then, ultimately, I would've missed my dance."

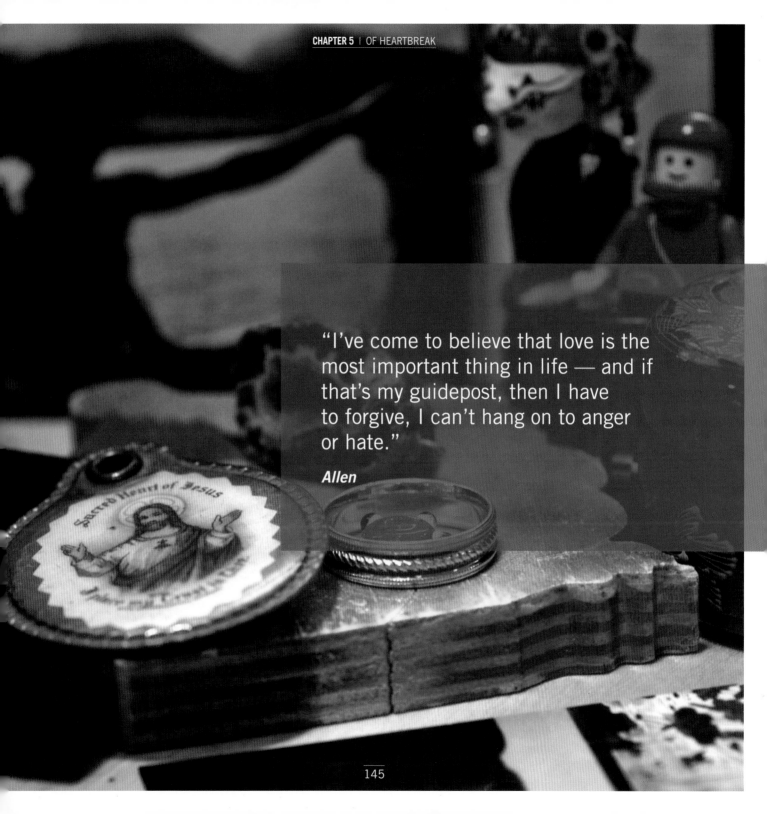

"I've come to believe that love is the most important thing in life — and if that's my guidepost, then I have to forgive, I can't hang on to anger or hate."

Allen

One Good Thing

About fifteen years ago, I convinced myself that my life had fallen completely apart, never to be put back together again. I was in my late twenties and my first marriage had ended. After taking the bar exam (and barely passing), I moved out into an apartment on my own and was promptly laid off from my first legal job ever. I was jobless, alone and running through my savings. Fast.

In short, I was a mess.

Understandably, my outlook on life seriously deteriorated. I began believing that every major move I had ever made was completely without logic or basis, that I was incapable of making a sound decision. I became depressed, and I stopped eating. And since I wasn't in a relationship and didn't have any children, I started having thoughts — fleeting thoughts, mind you, but they were there, just the same — that perhaps it would be better for the World at Large if I simply … went away.

Then, one day, as I was lying in bed late at night, trying to fall asleep and failing miserably, I remembered the first two lines of a childhood prayer my grandmother taught me many decades earlier:

Jesus, safe in Mary's arms,
thank you for this day.

As I lay there, I felt myself growing angry. "Thank you for this day"? Really? My life was seriously *sucking wind*

lately. How the hell was I supposed to thank *anyone* for that day?

But then I thought, *well … maybe there's one thing that was good about this day. If I can think of one thing to be thankful for, then, maybe, the day isn't a total loss. Maybe it's worth sticking around to see tomorrow.*

So I thought.

And I thought.

Then suddenly I remembered that earlier that day, in a fit of defiance and even though I really couldn't afford it, I stopped by a coffeehouse for a cup of coffee. When I was about to enter the building, an older man who was ahead of me grabbed the door, opened it wide and stepped aside to let me in, smiling warmly as he did so. I remember thinking to myself, *goodness, that was really nice,* and weakly smiling back.

Okay, I thought as I lay there in bed. *A stranger showed me a bit of kindness today.* That's one good thing that happened today. I felt just the tiniest bit better.

And then I fell asleep.

Since that night, every night before falling asleep, I think about at least one good thing that happened to me during the day. At first, it was very difficult — the decidedly insignificant fact that I'd perfectly boiled an egg for my morning breakfast featured heavily as a "good thing" in those early days. But slowly, and ever-so-surely, I found that I was able to come up with one, sometimes two, eventually three and even occasionally more occurrences in my day that were good things. And after a few weeks of doing this nightly practice, I found myself consciously looking for events during my day that were Good Things, things that made me think, *cool, I'll add that to my list tonight.* And amazingly, my outlook began to change. I became more confident. Slowly, I was able to turn my life back around.

And I'm proud to say that in fifteen years, there's never been a day when I couldn't come up with something that made my nightly Good Things list — even during the worst possible days.

Because it turns out that as long as there's One Good Thing, I can keep believing in Hope. And sometimes, that's all I need to keep going.

The Unofficial Bartender – Recommended
List of Ways to Add Some Good to Your Otherwise Really Bad Day

One cold, wintry afternoon, I found myself with a bit of free time, so on a whim I stepped into my local watering hole to warm up a bit. Everyone should have a place like this in their lives: it's a small space, with only a few tables and stools, and the bartenders are the kind of folks who call you by name, remember your favorite meal or beverage and are generally ready with a quick smile.

On this particular day, I struck up a conversation with the three young people working behind the bar — two women and one man (whose names are withheld to protect the innocent). As we talked, I suddenly remembered a question that I've wondered about for a long time, and since I had these three professionals at my

disposal, I decided to ask: "So, is it true that people tend to pour out their hearts and heartbreaks to bartenders?"

They hesitated, glancing at each other nervously.

"Oh, I don't *need* anything," I quickly said. "It's just the stereotype you always see in movies, you know? Guy loses job (or girl), guy staggers into a bar and lays it all out on the unwitting bartender …"

"Yes, it happens all the time," one finally responded. The others nodded in agreement. "It's like we're therapists."

"All right, then," I said. "So when the bartender is going through a rough time, who does the bartender talk to? Do you talk to each other?"

"Well, yeah, sometimes," said one of the women. "But, you know, there are other things I do that help me feel better."

"Yeah? Like what?"

Thus began a pretty high-spirited discussion among the three of them about the things they do to help them get through a particularly heartbreaking time. So, in no particular order, here are some of the things they told me:

- "Chocolate. Really good, creamy, dark chocolate."
- "Crying. A lot. Until I can really cry no more."
- "I like to work out. Sometimes a good run can really clear my head."
- "I love cooking. Cooking a really great, healthy meal. Or actually, when I'm upset, I make lots of cinnamon rolls. I don't even like cinnamon rolls — I have to ask friends to come get them out of my house the next morning!"
- "I make lists. Lots of lists. Lists of good things in my life. Or to-do lists — especially ones that include things I've already done, so I can cross them off immediately."
- "Sleep. Sometimes a good, long, self-indulgent sleep is called for."
- "Call a Friend with Benefits. People don't like to admit it, but sometimes nothing comforts like kind, caring, but no-strings-attached sex."
- "Road trip, honey. Just get in the car and drive."
- "Build a bonfire. Or at least a fire in the fireplace. Write all the negative stuff down on paper and watch it burn. Or, you know, burn all the stuff owned by the person who really pissed you off." [Editorial Note — I don't recommend this.]
- "Gardening. Sometimes it feels really grounding just to get your hands in the dirt."
- "Go to a firing range. That really helps get the anger out."
- "I clean. My husband knows that when I'm cleaning the grout, he needs to just leave me alone and let me work through it."
- "Get good friends together. Give and get lots of hugs."
- "I scream. Loudly. Into a pillow. Or, actually, sometimes not in a pillow."

- "Snuggle with your pets. Pets are always awesome."
- "Create. Create anything. Write. Draw. Paint. Do something creative, even if the result isn't for anyone else's eyes."

Eventually the time came for me to leave. I finished my glass of wine, said my goodbyes and went on my way, but this conversation stuck with me. The more I thought about it, the more I realized each of the bartenders' different ideas was really just about taking a minute to focus on something a bit out of the ordinary, to turn on a part of the brain different from the one focused on heartbreak, if only for a moment. While chances are that none of these activities would make the pain go away forever, each of them might just provide a bit of a break for a moment.

And let's face it: when we're going through a tough time, a bit of a break is often what we need most.

of language

"A special kind of beauty exists which is born in language, of language and for language."

Gaston Bachelard

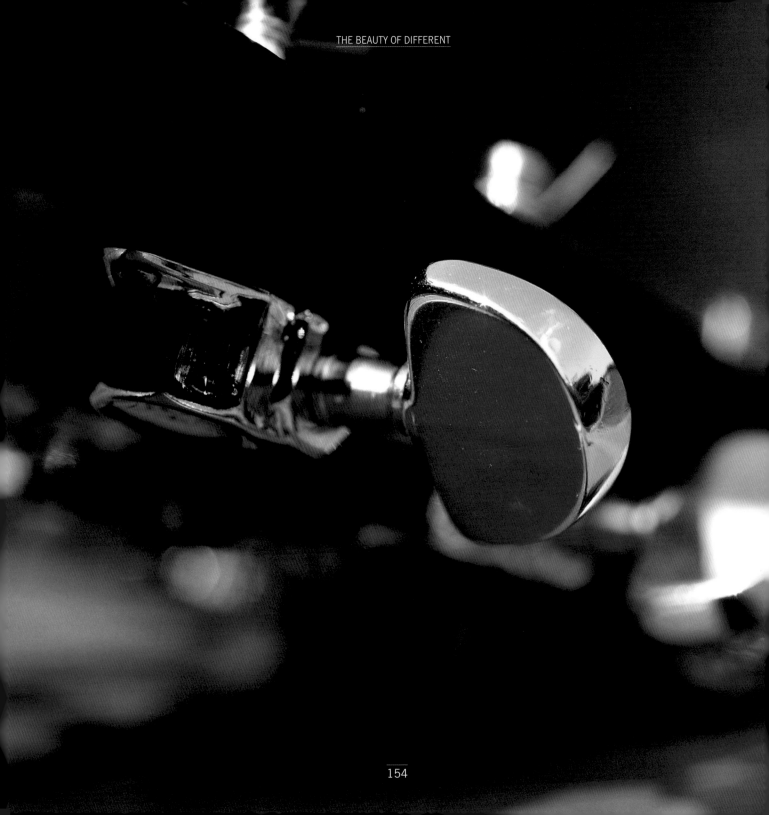

Views on Language

We arrived in Avignon, France, we three women, by train. We were halfway through our summer holiday to Europe, and after the bustling, cosmopolitan city experience of Paris, we were excited to see the rest of the country. It was funny: a week earlier, I wouldn't have been able to identify the small town of Avignon if it had been highlighted on a map; yet here we were, three single women on an adventure in the south of France.

Pam, Kathy and I found our way from the train station to the tiny hotel we had booked for our short visit — a drab, brown, generally unimpressive-looking building, but our room was clean and it had three comfortable beds and a private bathroom. We could hardly complain. We dumped our bags and as the sun began to set, we headed out to do a little sightseeing before dinner.

Avignon is a small town on the banks of the Rhône river, in the Provence area of France. The town is surrounded by fields of sunflowers and lavender, and of course, in the center is the hugely impressive *Palais des Papes*, an imposing palace where several popes (or antipopes) made their home in the fourteenth and fifteenth centuries, claiming to be the

155

true heads of the Catholic Church, as opposed to those who were seated in Rome. Near the *Palais* was a large square, with beautiful outdoor cafes and open-air vendors selling their wares. As we strolled toward the restaurants, we stopped by one vendor whose table was full of silver jewelry — rings, pendants, bracelets.

"Est-ce que vous cherchez quelque chose en particulier?"

I looked up. A short man with skin the color of hazelnut, long, shiny black hair and kind eyes was smiling at us.

"Je suis desolee," I began tentatively. *"Je ne parle pas français tres bien. Parlez-vous anglais?"*

"Yes," he said. His eyes scanned our little trio. "You are all American?"

His accent was not French.

My friend Pam spoke up. "Yes, we are. Where are you from?"

"Peru," he said proudly.

"Ah," I responded. *"Soy de Trinidad y Tobago."*

"¡Tu hablas español!" he exclaimed.

"¡Mejor que hablo frances!" Better than I speak French, I laughed. He laughed. His name was Pablo.

My friends and I admired his silver jewelry ("from South America," he explained), and then we turned to leave. It was time for dinner.

"What are you doing after dinner?"

We looked at each other nervously.

"I … I don't … we don't know yet …" I stammered.

"Well, after dinner, come back here," he said.

Our faces registered our doubt.

"No, really, come back. I promise. It will be good."

"Okay," said Pam. "We will."

We went to dinner, the three of us, and as we sat down in a lovely café not too far away, I asked my friends nervously, "Umm … should we be agreeing to meet some strange man after dinner?"

"Sure," said Pam. "Why not? I mean, there are three of us. What could possibly happen?"

I reluctantly agreed. We ate our delicious meal of local, Provençal dishes, local wine and fresh baguettes (me ordering for my travel companions in my broken, apologetic French) and after dinner, we returned to Pablo's stall.

When we arrived, all of the jewelry had been packed away in his case, and he

was busy folding up his table. This time, however, he wasn't alone: there were two other men with him, taller, both smoking cigarettes. And there was a woman, also smoking a cigarette. My confidence began to drain as I wondered what we were about to get ourselves into.

"You came back!" said Pablo. "Come! Meet my friends."

Pablo switched from English to French to speak to the two men, introducing us all. Then we watched as one of the men spoke to the woman in a different language — Italian — and she turned to us and smiled. "Pleased to meet you," she said haltingly in English.

"Pleased to meet you too," my friends and I responded in unison.

"Come," said Pablo. He pulled a bottle of wine out of thin air. "Let's go."

By this time, it was about ten o'clock, and the sun had gone down. It was a beautiful summer night. We all started walking, and I noticed that one of the French men was carrying a guitar case. I walked over to him. "*Vous etes un musicien?*" I asked. It was an obvious question, but I felt like I needed to say something.

"*Oui,*" he said, raising his guitar case toward me. His brow furrowed, as he tried to think of the words he wanted to say in English. Finally he just gave up, and he grinned. "Rock and roll!" he exclaimed.

"*Ah, vous aimez rock and roll?*" I smiled back. He nodded. "*Moi aussi.*" Me too.

"*Tu es une musicienne aussi?*" he asked.

"Me? Oh no," I said immediately. "*Mais … je … chante…?*" I wasn't sure if I just told him that I like to sing or I liked to eat, but I figured I'd try to respond anyway.

"*Idéal,*" he grinned. Suddenly the group stopped. We were on the steps of the *Palais.*

Pablo sat down. "Sit!" he said. We all arranged ourselves on the steps. The Italian woman sat next to me. "You American?" she asked.

I didn't even begin to know how to explain that while I lived in the United States, I was from the Caribbean. "Yes," I half-lied. "You?"

"Italy," she smiled. "I don't speak English."

I smiled back. "I don't speak Italian." She laughed.

What happened next was uncanny. Pablo retrieved the wine from his case and poured us all cups, and the guitarist pulled out his guitar. He began playing — a rousing song in French, and Pablo and his friends all sang along, boisterously. Pam, Kathy and I watched in wonder, swaying to the beat. When they were finished, we all clapped. Then the guitarist looked at me, "This one?" he asked. He started playing again.

And singing:

"Dares a lay dee who zhoor

All zat gleeters eez gold

And zhees buying a stairway to heaaaven...."

I started laughing. "Stairway to Heaven" seems the universal song for all guitar players everywhere, and apparently Avignon was no exception. We all struggled to sing along with the lyrics, but the truth was, none of us knew very many of the words. The guitar player tried again. "This one!"

He began playing, this time a much livelier tune:

"All moze heaven, Wess Urgen knee ya

Blue reedge mountain

Anna Oh Ah Reever ..."

This time, my friends laughed along with me. And at the chorus, we all belted it out:

"Country road, take me home,

To the place, I beloooooong....

West Virginia ..."

After the song ended, the ice was officially broken. My friends and I, filled with wonder, laughed uproariously, amazed that here, in a small town in France, the words of John Denver were alive and well. We continued to sing: they taught us French songs, we helped them with the lyrics to English ones. We even started to tell jokes: one of my friends would tell the joke in English, I would help make sure Pablo understood by translating the trickier bits into Spanish, he would then translate in French, and then the Italian woman's French boyfriend would explain it to her in Italian. Each joke took forever, but we would all laugh hysterically as each person in turn eventually got the joke. The bottles of wine we consumed that night likely helped. The plaza emptied, yet the entire night was filled with our laughter and our singing. Before we knew it, it was four o'clock in the morning.

Knowing that we had a long day of sightseeing ahead of us, my friends and I finally, reluctantly, decided to say goodbye. We exchanged warm, heartfelt hugs with our new friends. As we turned to go back to our hotel, I'm not sure we realized that was the last we would ever see of Pablo and the others. Yet even now, over a decade later, the memory of that night is strong and cherished. Here we were, seven people who didn't speak each other's languages save for a few words, yet we all made a strong connection that night, just because we made the effort. That night, I felt the power of language, the power of communication and the beauty it is capable of creating.

Because yes, although I never saw Pablo again, I'll never forget him, either.

" I'm **different** because I spent the **majority** of my childhood in rural Louisiana as the only **Asian kid** in town. Living the small town southern life while retaining my **Filipino heritage** has given me a **unique** perspective on **fitting in,** despite sticking out like a **sore** thumb. "

Brian

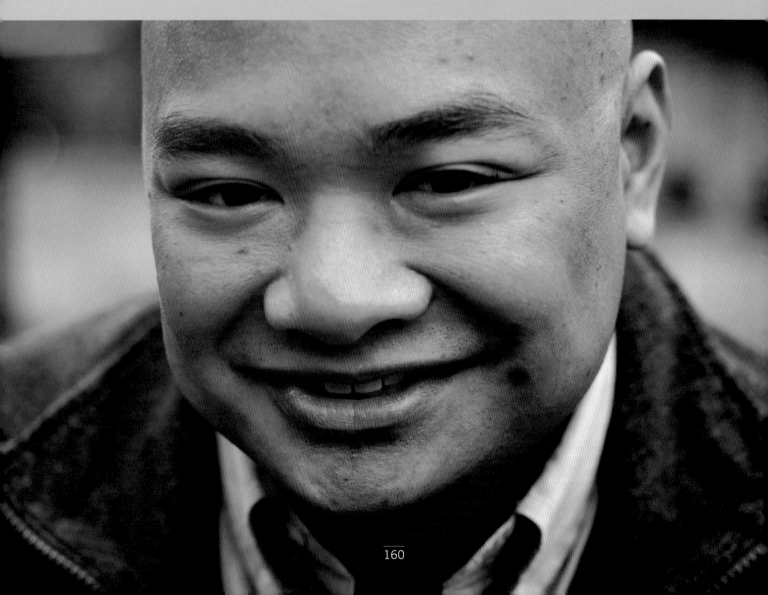

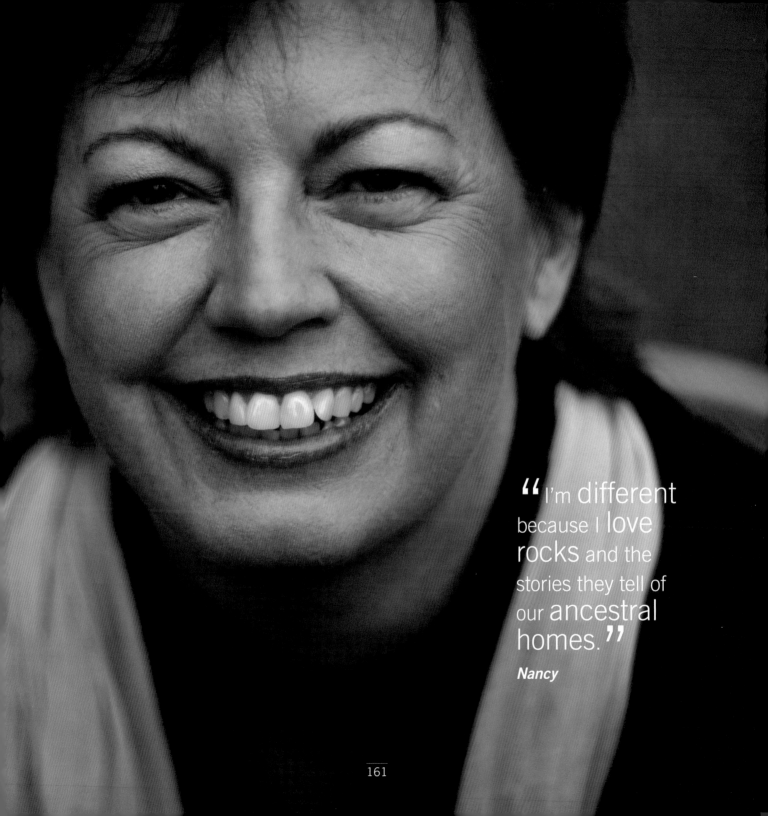

" I'm different because I love rocks and the stories they tell of our ancestral homes. **"**

Nancy

161

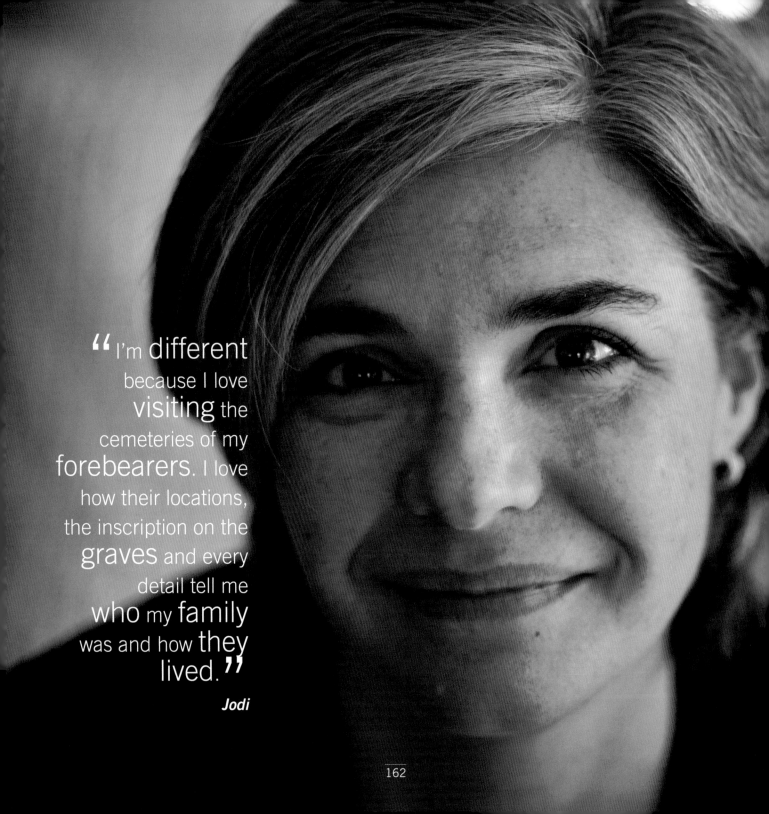

" I'm **different** because I love **visiting** the cemeteries of my **forebearers.** I love how their locations, the inscription on the **graves** and every detail tell me **who** my **family** was and how **they** lived. "

Jodi

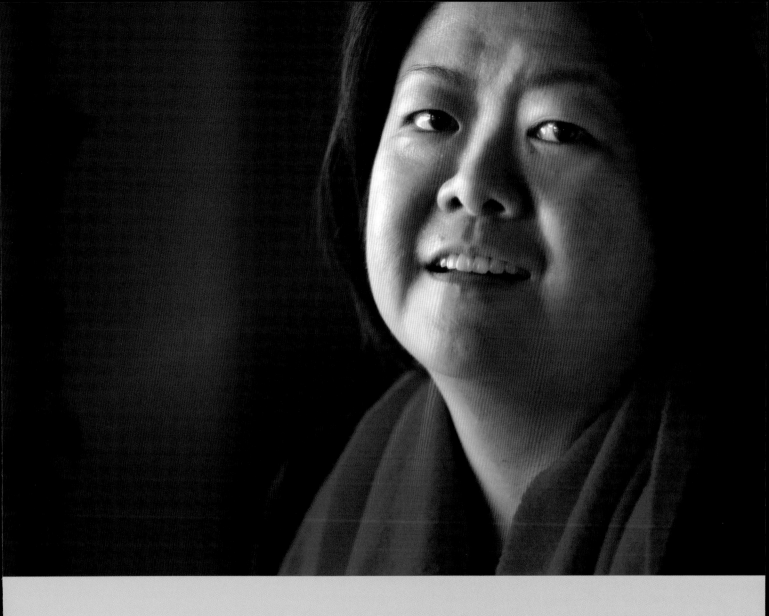

"I'm different because I can count to ten in at least eight languages.**"**

Sau Mei

A Closer Look: Irène

"Today, remember to be certain in your own strength. To make peace with the transformation of body and mind that accompanies becoming a parent. To place disproportionate value on rain puddles, vanilla ice cream and comfortable shoes. And find solace in the unconditional trust that your child places in you as he grabs your hand before crossing the street.

Today, remember. You are good enough. Your voice matters. Believe it. It doesn't take much more than that, I promise."

IRÈNE, SEPTEMBER 2, 2009

I don't actually remember when I discovered Irène's writing, I just remember always being enamored with the way she would string words together and how lyrical her sentences were. Reading them almost felt like listening to a sonnet: she described her life as a young mother of twin boys in Paris with such simple beauty, such tenderness, it was difficult not to crave more. As I sought her writing, I developed an image of what she must be like: *she's Korean-American,* I believed, *a former English major who attended a small liberal arts college on the east coast of the United States before studying abroad in Paris for a year. There, she met the man who would become her husband, and she decided to stay …*

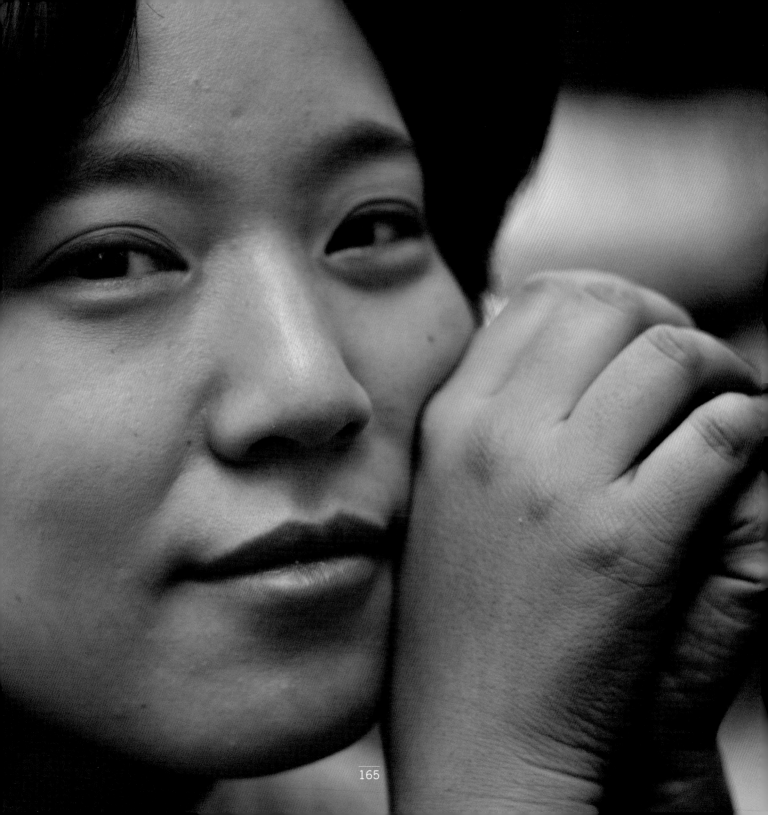

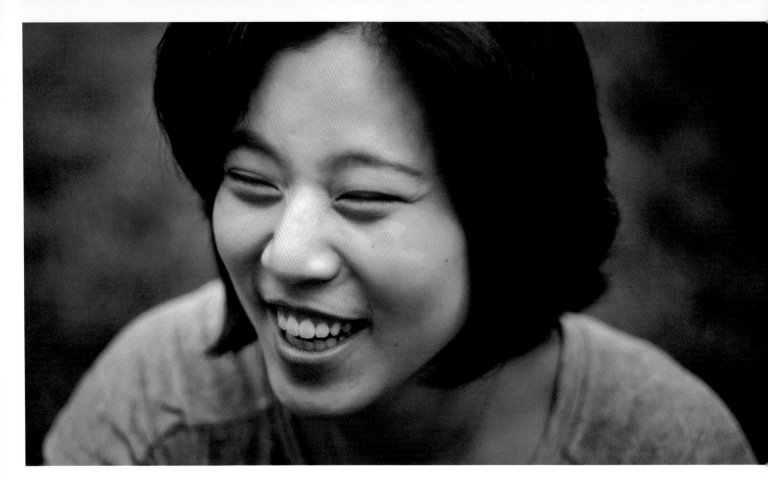

I could not have been more wrong.

It turns out that Irène, while certainly the daughter of Korean parents, was actually born in France. The first few years of her life she spoke solely Korean with her family, and she didn't speak French until she was older.

English, it happens, is her *third* language.

The thing is, Irène is beyond conversant in English — she has far surpassed fluency. Irène has become so masterful, she writes in English to a degree most native speakers rarely achieve. So when I learned that Irène was going to be in Chicago at the same time that I was visiting, I leapt at the chance to spend some time with her, to explore why it had been important to her to learn a third language so adeptly.

We managed to schedule some time together between meetings and shopping trips, and because Irène was feeling rather jetlagged from her flight from Paris the day before, we thought it best to get outside and grab some fresh air to help revive her. We walked to Millennium Park, in part because it was a landmark that neither of us had yet visited, but also because we both had our cameras with us and were looking for some photo opportunities. The day was gorgeous, so eventually we just collapsed under some trees to enjoy the weather (and for Irène to enjoy her first Chicago hot dog).

I decided not to beat around the bush. "Okay, Irène," I said, stretching out on the grass, "you're of Korean descent, born in Paris and speak both languages fluently. Why would you ever learn a third language? When did you decide you wanted to learn English?"

"Well, I was about nine years old, I guess," she began, as she munched on her hot dog. Though we'd spoken on the phone before, I never stop being startled by how strong her French accent is, and as always, I remain very charmed. "My first language is Korean, but I started learning French at about age three. As a very young child, I used to spend summers in Korea so that I would remain fluent in both. Then, at about age nine I started really loving music — American pop songs in particular. I'm an only child, and when you're an only child, you get to spend a lot of time alone in your bedroom." She started to laugh. "Do you remember Glenn Medeiros?"

"Umm … I can't say I do …"

"He sang that song 'Nothing's Gonna Change My Love for You.' Don't you remember?"

She thought for a moment, and then began singing: *"Nothin's gonna change my love for you …"*

"Oh, right!" I laughed, and then joined in: *"You oughta know by now how much I LOVE YOU!"*

She giggled. "Exactly! I loved that song. And I remember playing it over and over again, and wanting to know what Glenn was singing. So I'd get a notebook and write the words phonetically: *nuh sing go nah change mah luv* … And I would practice constantly. It wasn't until much later, after a few years of studying English, that I finally figured out what the words were. I remember smacking my forehead and laughing out loud to myself. And I won't even start on 'A Song for You,' by Beautiful South. I was eighteen before I realized he was singing girls' names." She laughed. "But you know what? The dedicated attention to lyrics really helped me develop a good ear, I think. I did it for years after, listening to English songs and writing down the words. Eventually, I did it properly, though," she grinned.

"Wow. That's some focus."

"I loved it. I really loved music. It was my first entry into learning English."

"So how old were you when you finally started learning English in earnest?"

She thought for a moment. "About twelve, I think. I was in junior high."

"Did you like it? Learning it formally, I mean?"

"It was so easy for me. I think I was so used to switching back and forth between Korean and French. But I became really serious about it in high school."

"Yeah? What happened that it became so important to you?"

"I fell in love with American movies. I'd always loved them: *Rocky* and *Back to the Future* were the first movies I saw in the theatre when I was a kid. Then when I was about 10, I went through a huge *Star Wars* phase. By high school, I really became enamored with movies and started dreaming about working in the film industry — I even wrote my Oscar acceptance speech, in English! I wrote screenplays, short stories … I was totally influenced by Quentin Tarantino, James Gray, Kenneth Branagh … I loved them all."

I laughed. "Honestly, Irène, this makes no sense to me. I mean, yeah, those were cool movies and great

filmmakers, but the French are sort of renowned for making cinematically ingenious movies, aren't they? Why look beyond those? Why American movies?"

"They're fantastic! Besides, French films, for a long time, had a reputation for being for elites — having lots of unnecessary words to make them seem loftier. And I never got French humor, isn't that strange? But American movies — really, they're fantastic. They're highly entertaining and moving and universally funny. The endings are always so great: the ordinary girl always gets the cute boy, and everyone always lives happily ever after. Even today, I prefer American movies. They made me want to be a Hollywood movie-maker. It was my dream."

I smiled, moved by her ability to articulate the way culture affected American and French film genres. "That's awesome. Were there any other movies, in particular?"

"Oh, all of them. I remember that I would go to the movie theatre to watch them, and I'd try to get into the theatres where they were showing them with subtitles — which, actually, wasn't all that easy because most of the movies were shown dubbed into French, which I hated. I didn't want to be removed from the experience of listening to the English language."

"That's so interesting. I mean, I can see why dubbing can be annoying, but as a kid, surely hearing the movie in your own language would've been easier. I can't imagine making watching a movie that much harder on myself, particularly when I was a child."

"Do you think so?" She seemed genuinely confused by my reaction. "I don't know, I just wanted to see the movie as the screenwriter intended. I wanted to see it in the original language. I was the same with television … well, with one television show in particular: 'Saved by the Bell.' Do you remember that show?"

I laughed. I did.

"I loved that show. In fact, I won a TV contest to meet the cast."

"You are kidding me."

"No! I had to answer three questions — I can't remember what the questions were right now — and me and five other students won. We got to have dinner with Zach and Kelly — I mean the actors, of course, Mark-Paul Gosselaar and Tiffani Thiessan. It was at the Hard Rock Café, in Paris."

"That's hysterical, Irène. Did you talk to them?"

"I was so shy! But the other kids who were there couldn't really speak English, so I ended up translating for most of them. I think the only question I asked of my own was to Tiffani, and I asked her something silly like, 'How many babies do you want?'"

She giggled at the memory. I laughed with her.

"So," I asked, "have you ever been to Hollywood?"

"Yes!" she answered immediately. "When I was about seventeen years old, I visited America for the first time on a school tour. I went to New York City, Washington DC, Las Vegas, San Francisco and Los Angeles. While in LA, I visited Universal Studios. And it was great. But you know what impressed me the most?"

I shook my head.

"New York City. I remember when we landed, the first place we visited was Central Park. And I remember it was a beautiful day, and there was a baseball game going on in the park. It was so cliché, and yet I was so enthralled! It was exactly as I pictured America would be."

I smiled in recognition. I remember when, at age eleven, my family moved to the United States. I was going to be in "junior high" — a level of education that sounded impossibly grown up to my adolescent ears — and I'd concocted an elaborate fantasy, based heavily on American after-school television specials, of what "junior high" would be like — lockers, cool girls adorned with handbags and high heels, and perhaps even spontaneous dancing on the cafeteria tables. I'm proud to say that my perceptions were 90% accurate.

"So, after having confirmed what American life was like, you returned to Paris. Then what?"

"Well, when I was eighteen, I enrolled in the Sorbonne, to attend film school, as I'd always planned. I studied the theoretical side of film, like film history and how to write and edit films. It's there that I fell in love with the American film musical. Oh, and also Charlie Chaplin."

"Really!" I said. "What was it about him that you loved?"

"It was how he could magically express himself using very few words. That's how I like to be. I like to be … curate … with how I use my words."

I smiled. "See, what you just said there … that's exactly what I'm talking about with you — the way you use the English language is really creative."

"Wait, did I say something wrong?"

"No … it's just … the word 'curate.' In English, we use that word as a verb, and usually only with art. Like, you'd 'curate' an art exhibit. But the way you use it, as an adjective, it works, because with you, you clearly see and use language as art. Ant it's apparent when you write, you are very careful with the words you use. You're … 'curate.'"

She smiled shyly. "Well, I suppose since my introduction to English was through music and film, I *do* see it as an art form."

"Are you like this with all the languages you speak? Are you as floral and poetic?"

She thought for a minute.

"I think French is the language that is most me. French is very rough, very raw. When I'm angry, I always speak in French because it is the language that is the most elemental for me. With English, though, I can play with the words. I can't make beautiful sentences in French, but I can in English — the words look and sound beautiful together."

"That's really interesting," I said thoughtfully, "because I think many English speakers would say that French is the more beautiful-sounding language."

"Oh, it's pretty, I suppose, but you can't play with it like you can English. At least, I can't."

"And what about Korean?"

"Well …" she said slowly "… Korean has so many more words than the French language has. I feel like

Korean helps me complete my vocabulary.

"But English … English is so universal. I like that when I write in English, I can be read and understood by so many people. It puts me on the map in some way. It helps me say 'here I am.' I am heard. It allows me to leave a trace, make a mark on the world."

I thought about Irène's concept of her three languages, how they complement each other. Generally, I don't believe people think of languages as being able to fill in the gaps of each other — when we learn a language, we learn it, I think, from the perspective that we are simply re-learning our normal way of communication in a different tongue. But now, I see it can be more than that. As I thought more about it, even the way I've learned to speak English, in both my countries — Trinidad & Tobago and the United States of America — there are certain idiomatic expressions in each that capture feelings and emotions not easily expressed in the other country's "language." Only in America could I ever "hit it out of the park" — in Trinidad, I merely "succeed." And in Trinidad, I might suddenly "catch a vaps" to the shock of everyone around me — but in America, "doing something unexpected," might merely raise an eyebrow. Each dialect, each version of English has its own uses, its own way of communicating my feelings and experiences. So it should obviously follow, I suddenly realized, that it would be the same with three distinct languages. How freeing it must be for people who learn even more, or even take the leap to emigrate to another country to immerse themselves in a new, foreign tongue.

I wondered if this freedom also translated into the assimilation into various cultures as well.

"Since you're fluent in these languages, do you think you're able to move among cultures pretty easily, as well?"

"Well, I'm very French," she said thoughtfully. "When I was eighteen, I made the unconscious decision to be Korean — to live a Korean life, to have Korean friends, marry a Korean man — but since my children were born, I've come to realize that even though I've done all of these things, in actuality, I'm very French. So I don't know if I'm able to move among cultures easily, but I certainly understand them in a way that I may not have if I didn't speak the three languages as well as I do."

"Do your sons speak all three languages?"

"They speak French and Korean. We speak Korean at home. Unless I'm angry," she smiled. "When I start speaking in French at home, my sons know that I am serious."

I smiled.

"How do you think their ability to view or understand cultures has been affected by their bilingual ability, or watching their mother be trilingual?"

"Well, I think culture is in everything … it's even in the way you brush your teeth, if you think about it," she responded. "Language is a way to help bridge the gaps between the cultures. It has given my sons the ability to adapt to any situation, I think. We can go to New York or Korea, and they just adjust themselves. Also, and what I'm happy about most, I guess, is that they aren't upset when someone speaks a different language, even if it's one they don't understand, like some kids their age might be. They just get the fact that people speak different

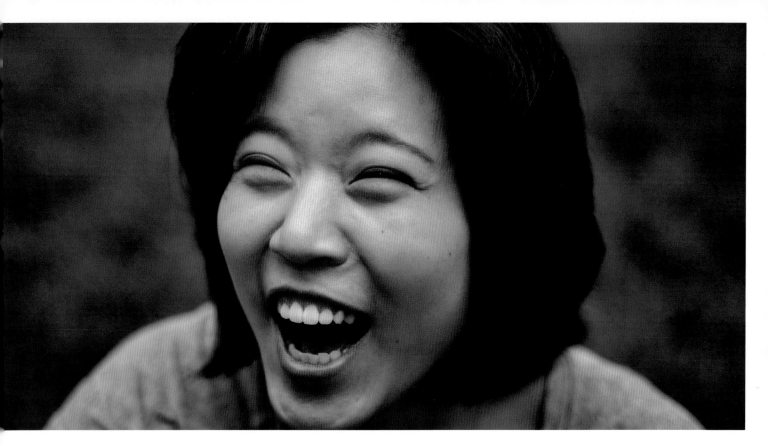

languages, have different skin colors. Sometimes we speak Korean in the streets of Paris, and kids look at us like we're aliens. I'm happy my own children don't behave that way. I believe that speaking different languages is a door to tolerance and respect for others. Hopefully my children will see this. Hopefully they take the best from all the cultures that I've come to love."

"What, specifically, do you hope they learn?"

"Well, I hope, from the Korean culture, they learn how to respect their elders and how to take care of older people. I hope they learn that the elderly can enrich our lives. From the French culture, I hope they grow up to be decent men and helpful husbands. I hope they learn independence."

"And the American culture?"

She laughed. "From the American culture, I hope they learn to dream big. I want them to know that anything is possible. That when you follow your heart, it can take you anywhere."

"Live the 'American Dream'?"

"Exactly."

I love the concept of language being the gateway to tolerance and respect, and I believe this. As someone whose speaking accent is somewhat shaped by various countries where I've lived, I know that I have sometimes been received with some skepticism by each country's local population as a result. Similarly, I've often been

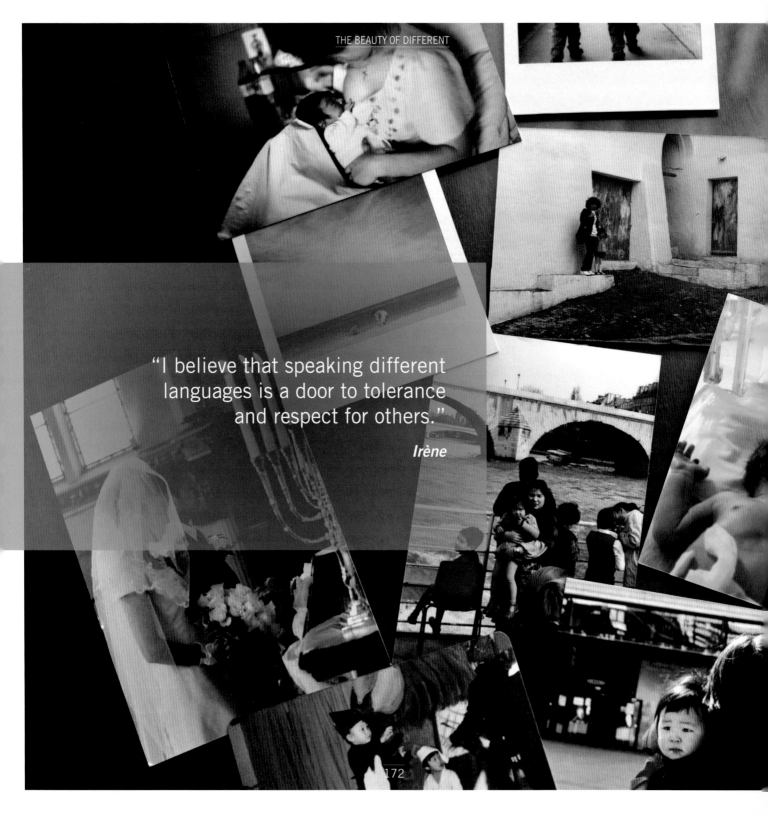

"I believe that speaking different languages is a door to tolerance and respect for others."

Irène

appalled by how quickly I have seen tourists in various countries dismiss its native countrymen as being unintelligent, simply because they do not speak the tourists' foreign tongue. In speaking with Irène, it becomes so clear that an effort on everyone's part to value language — to hold it up as the art form it can be — could be a true path to understanding each other's cultures. Similarly, by valuing our own language — the way we speak, the way our voices are shaped by the different regions we call home or the way we've been educated or the travel we've made or our native lands — we can realize that this skill, our way of communicating, is really a beautiful Different we can claim for ourselves.

I asked Irène one final question: "Do you think you'll make your boys learn a third language? Or even a fourth?"

She thought carefully — curately — before responding. "Well, I don't know that I'm going to make them learn another language," she began slowly, "but just by virtue of attending school in France, they will learn English and at least one other language, probably Spanish — French kids have to learn two languages at school. But I'll definitely encourage them to learn additional languages. If you think about it, if I had never learned English, you and I may have never met, or I might never have traveled to the United States. But I did because I made the effort to learn a third language. I think in the end, what remains are the people in your life — and maybe my sons' future best friends or their soul mates are Spanish, you know? Maybe they're English. I would hate for them to miss the opportunity to have that connection with someone simply because I discouraged them from not learning another language."

I nodded in emphatic agreement. Without question, language has taught me that the ability to communicate was the doorway to experiencing the differences in other cultures, in other worlds.

And without exception, those experiences were very, very beautiful.

Rubbers & Buns

When I moved to the United States from Trinidad as an adolescent, I quickly discovered that my family and I didn't speak the native tongue. While the official language of Trinidad is English, I learned that Trinidadian English is nothing like American English. This fact was never brought home to me so quickly as one day during my first few days at my new American school, when I found I had made a mistake on my math work.

"Excuse me," I said, whispering to the boy sitting next to me. "Do you have a rubber?"

"What?" he practically shouted. "What are you asking me?"

I was completely confounded. "A rubber," I repeated, looking at him as if he'd fallen out of a tree. "You know, I made a mistake. I need to rub it out."

"Oh." He looked visibly relieved. "Here. And by the way, it's not a 'rubber.' It's an 'eraser.' A rubber is a condom."

In truth, at eleven years old, I didn't know what a condom was either, but a quick explanation from my embarrassed mother cleared everything up.

My favorite example of my family's lack of fluency, however, comes from my father. He was visiting West Texas on business, and his work colleagues had introduced him to that ubiquitous southern breakfast, biscuits with gravy. The next morning, my father's colleagues returned to Houston, so my dad found himself dining alone.

"What'll it be, hon?" asked the waitress in her southern drawl.

My father couldn't remember the name of the dish he'd had the day before, but was certain the word "biscuit" couldn't have been in its title, since in Trinidad, a "biscuit" is a cookie. So he described it the best way he knew how: "Um, I'll have your buns covered in gravy, please."

It is to my continued wonder that he wasn't arrested on the spot.

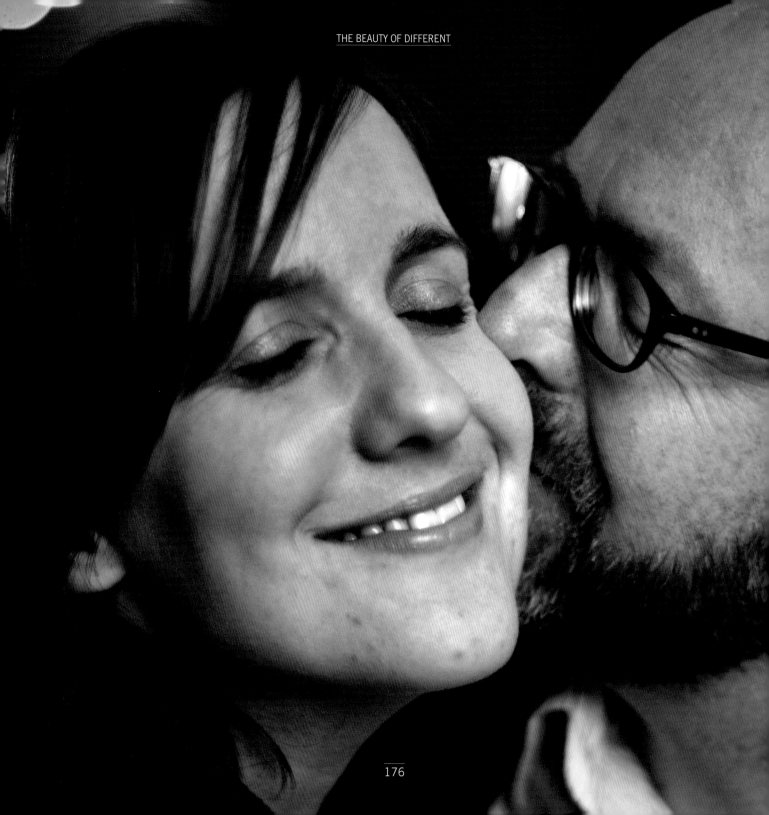

Hello

Having spent far too much of my life in airports, I've become quite adept at finding creative ways to bide my time while I wait. One way has been to observe friends and family from various countries greeting each other hello. For example, Americans tend to hug in greeting. The French — indeed, many Europeans — kiss, although I haven't been able to distinguish the countries where they tend to kiss once on one cheek from the ones where they kiss twice on either cheek … and I think I've even noticed a few people kissing back and forth from cheek to cheek quite madly for an indeterminate amount of time.

I've always wished I was a native of *that* country.

My favorite greeting, however, was seeing two men, each wearing full, flowing bishts, running toward each other. Suddenly each stopped short in front of the other and bowed deeply and formally before leaping into each other's arms, tears of joy running down their faces. These friends had clearly not seen each other in quite some time, and I couldn't help but feel I was witnessing a monumental moment.

I wish there was a way to collect these greetings so that I could look at them all at once in moments of sadness. There's nothing like the language of love, however expressed, in whatever circumstances, to really lift my spirits.

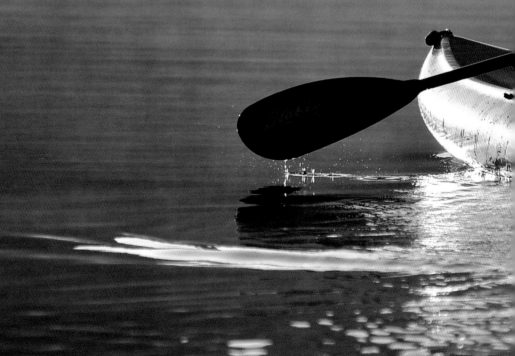

of adventure

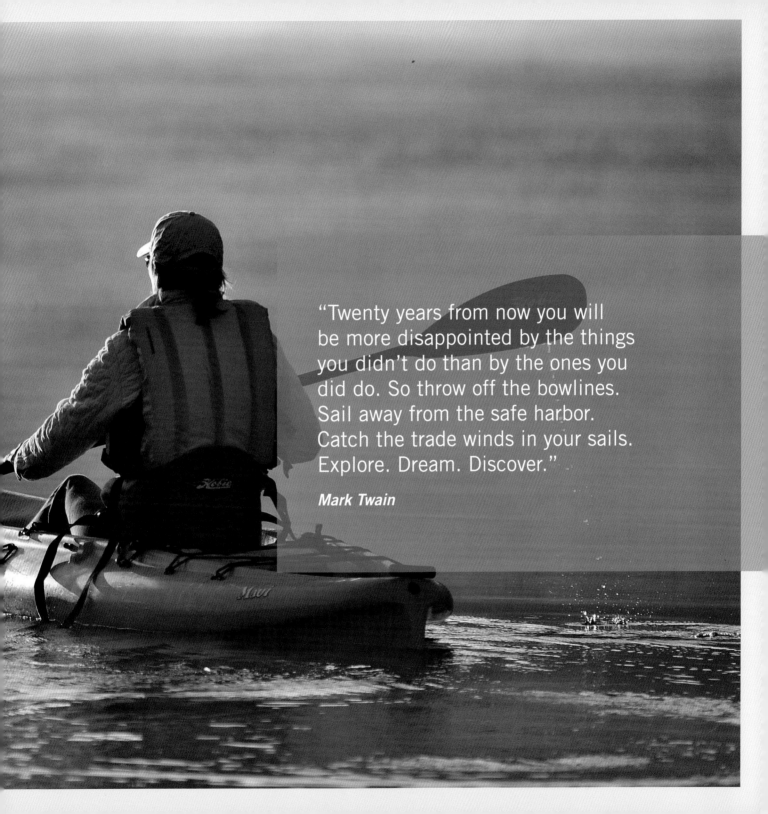

"Twenty years from now you will be more disappointed by the things you didn't do than by the ones you did do. So throw off the bowlines. Sail away from the safe harbor. Catch the trade winds in your sails. Explore. Dream. Discover."

Mark Twain

Views on Adventure

Many years ago, soon after my baby sister was born in America, my family returned home to Trinidad, my birthplace, for my father's brand new job. I was five years old, and having lived most of my life thus far in the United States, I was looking forward to living in a house on the beach, in the country where my mother and father had taken me on holiday so many times before to visit their moms and dads. And now, a new home with a baby sister! It was a very exciting time.

We quickly settled into our gray house at the end of a dirt road, with the fruit bats that rustled inside its ceiling, its sandy backyard and the sea beyond. The house was old and creaky (and, truthfully, the bats somewhat scary), but it was on the east coast of the island, and the sun rising up over the sparkling Atlantic Ocean every morning really was quite breathtaking, even to my very young eyes.

Soon after we arrived, my mother employed Jean, a large, older woman who kept her hair tied up in a colorful scarf. She had a strong propensity for loud laughter,

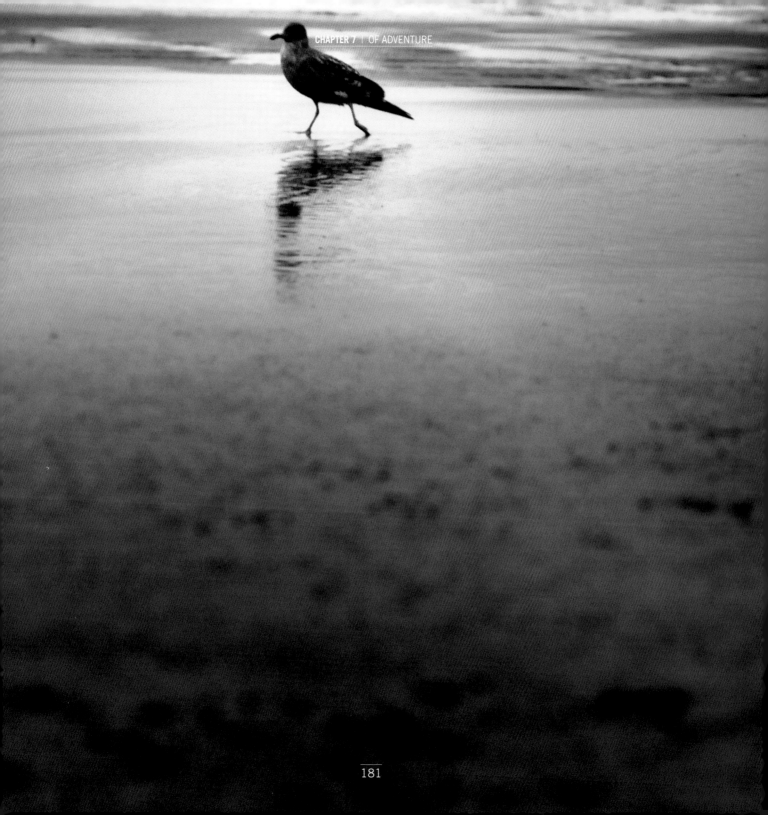

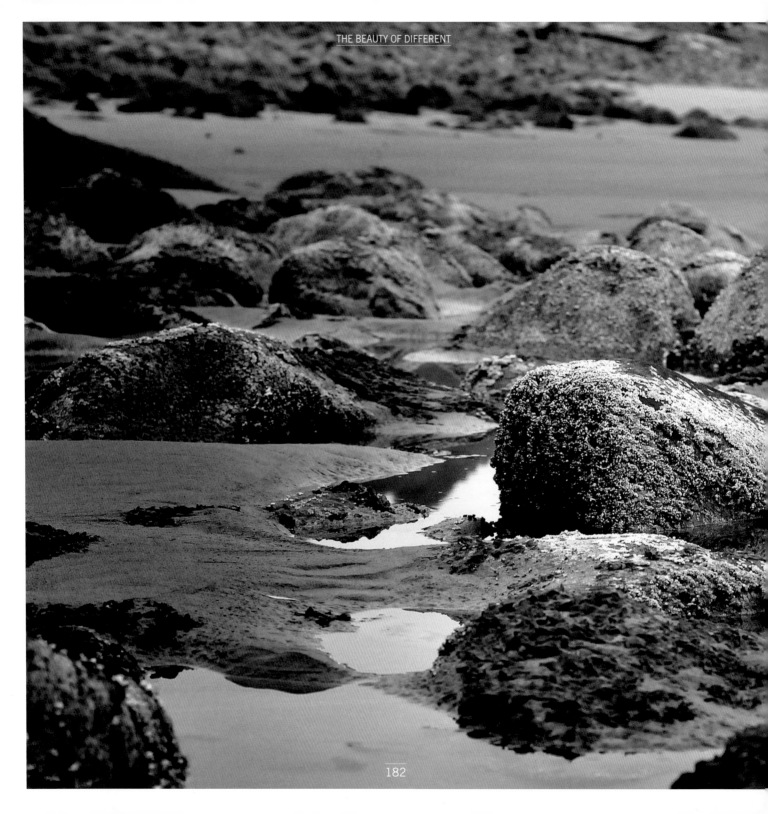

which was somewhat unfortunate, for Jean had approximately two teeth left in her entire head. I was both horrified and fascinated by her toothless grin. She helped my young mother with the housecleaning and the cooking — and boy, could she cook — and she babysat my sister and me when my mother needed to run into the village to do errands.

One very early morning, I felt her gentle hands shaking me awake.

"Come, dahlin'."

"What's happening?" I asked, sleepily.

"Come. Yuh goin' wit' me dong de beach. Come."

I awoke, and Jean helped me get dressed. My mother was busy tending to my infant sister, and my dad had already left for work. The sun had just cleared the horizon and was rising in the sky.

Jean and I went through the sliding glass door into our back garden and through the gate onto the beach. "Where are we going?" I asked.

"We goin' an' buy some fish. Yuh hear dat?"

I listened and heard a loud low noise on the morning breeze.

"Yes. What's that?"

"Das de fishermen. Come. We go help dem pull seine."

"What's 'seine'?"

"Oh gawsh, you could ask question, eh? Come nah man!"

We began walking in the direction of the sound. Eventually I discovered its source: a man was blowing through a conch shell.

"Why is he doing that?"

"He tellin' everybody de fish here. Come, leh we go wi' de fishermen."

I looked where she was pointing. There, standing among the breakers, were several men, pulling a huge net, or seine. They leaned backwards against the tension of the

ropes, and villagers were coming onto the beach, grabbing a length of the net and pulling along.

Jean and I walked into the lapping waves. She grabbed the net and gave me a section. "Now, pull!"

I pulled. It felt like the net wasn't moving, and I leaned, using my entire body to pull against the tension, just as the fishermen were doing. One of them, pulling next to me, looked into my eyes and smiled. He didn't have many more teeth than Jean.

We pulled and we pulled, and slowly the seine started making its way to the beach. As the water became shallower, the fish appeared, silvery, gasping for breath, flapping around in the morning sun.

After about twenty minutes of pulling, all the fish were on the beach. I was stunned at how many there were, and how many shapes and sizes. In addition to fish, there were a few stingrays and hammerhead sharks. I felt somewhat sad — thinking that just hours earlier they were swimming around in the ocean, minding their own business, and now they were lying here on the beach, slowly losing their lives. But I wasn't permitted to think about this too long: Jean grabbed my arm. "Come, child, we have to hurry, or de best fish will be gone."

The fishermen had quickly set up a makeshift fishmarket out of nowhere. Scales to weigh the fish appeared, and the villagers were pointing out the ones they wanted to take home.

"Boy, gimme two carite dey, yes? No, no, not dat one, de one dey! Yes, dat self … how much?"

"Yuh have any crab? Ah makin' a callaloo tonight, de man comin' home, ah *haf* tuh have crab, yes? *Fus* he go leave meh!"

Jean quickly chose a huge redfish and paid for it, as the man cleaned and wrapped it up in paper. She took the package and took my hand as we went home.

"Yuh had fun?"

"Yeah," I smiled. "That was cool."

"Good. We go make dis fuh dinner tonight for yuh mummy and daddy."

Many years have passed since that day on the beach with Jean. Since then, I've traveled all over the world, but every time I visit a country or experience a new culture, I think of that day. That day represented my first adventure alone, my first feeling of independence, my first real exploration. It was the first time I was experiencing something and crafting opinions for myself, without my parents' thoughts or outlook framing my own.

It was indeed the first time I discovered that by leaving what was familiar, what was comfortable, I could learn more about myself and my heart. It was an intoxicating feeling.

A feeling that all these decades later, I still crave.

"I'm different because I can **fly** a **glider plane** and I dream in **different languages."**

Katie

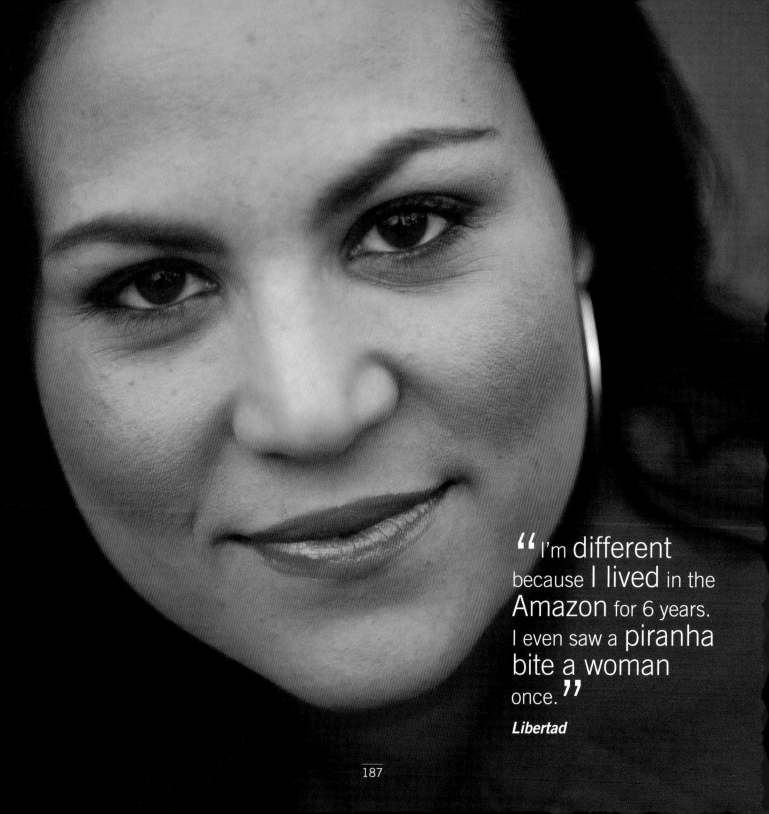

" I'm different because **I lived** in the **Amazon** for 6 years. I even saw a **piranha bite a woman** once. **"**

Libertad



187

" I'm different because there were more people in my first college class than in my entire home town. This fact has helped shape my world view: no matter where I go, I think of everybody as family. **"**

Grace

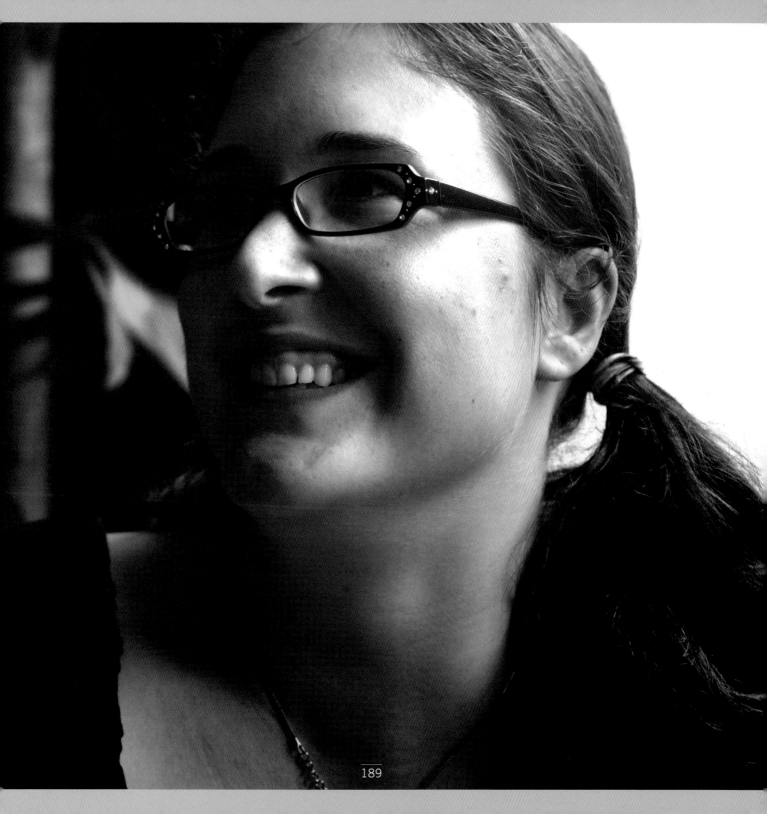

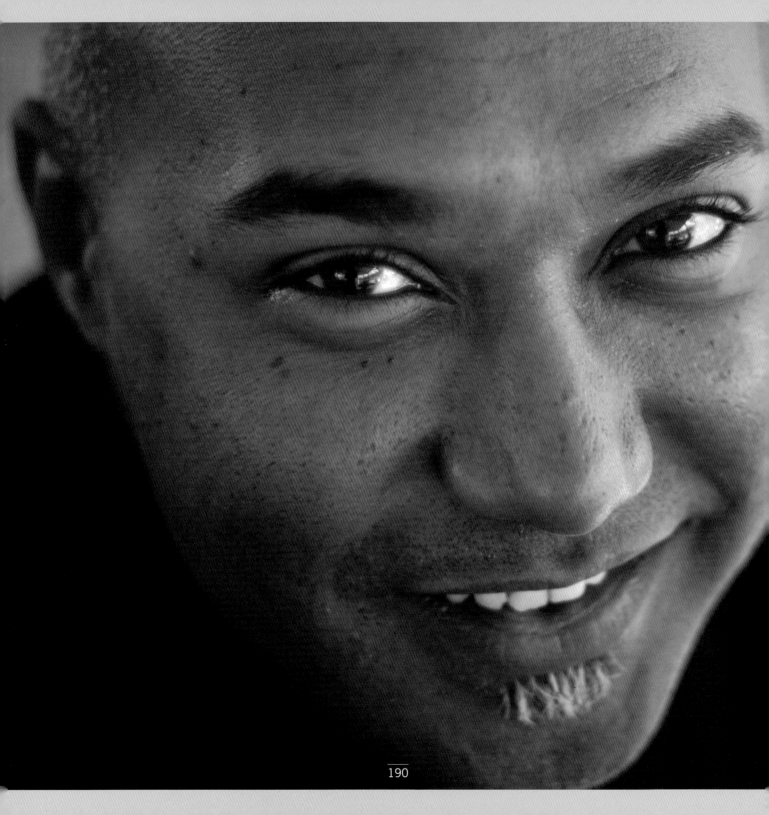

"I'm different because my **entire life** is an **adventure."**

Chris

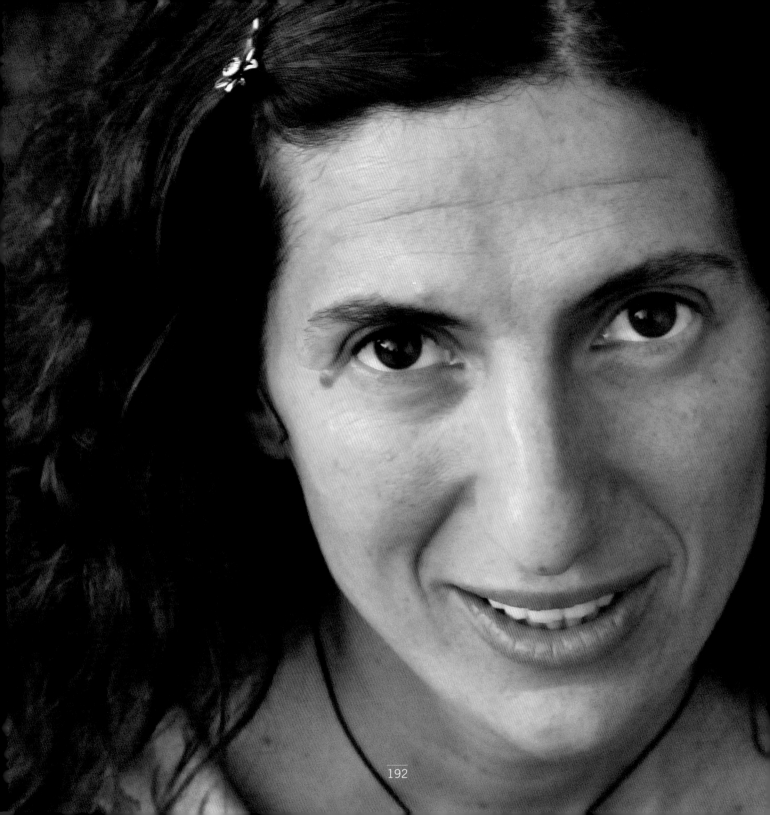

A Closer Look: Alex

To say that I was nervous on that late summer day when I boarded the plane bound for Oregon would be a bit of an understatement. I was petrified. I'm not sure what I was thinking when I had agreed to participate in a creative retreat with twelve other women in a large seaside house.

What was I thinking? I'm a lawyer in the oil industry, I'm not creative. I draft contracts for a living. Just because I shoot a few pictures as a hobby? This does not make me creative. I'm a total fraud. And these women — these women, most of whom I've never met in real life — will hate me. They will all be exuberant about their wildly artistic lives, and I'll just sit there dumbly like a mook.

And yet, despite my seriously foul outlook potentially risking the ability of these women to enjoy their beach retreat, I got on the plane anyway.

When I landed and met all of them at the airport, I found I was partly right: they were exuberant, but they were also warm and welcoming. It was lovely. However, through all the hugs and hellos and great-to-finally-meet-yous, I noticed a young woman hanging back, smiling quietly at the group. *That must be Alex,* I thought, remembering the information that had been sent to each of us about each other prior to the trip. *The traveler.*

I was right. Over that weekend, I slowly began to know this quiet, mysterious woman. Unlike many of the other women in the house, she was more reserved — a serene observer. I quickly discovered, via her soft Brazilian accent, that she was from São Paolo and was a visual effects producer in the San Francisco Bay Area. I also learned that she left her

native home to travel alone when she was seventeen. Seventeen. I was so intrigued.

Because Alex appeared very private, I didn't ask her too many questions on that trip to Oregon; however, over the years, we've developed a sweet friendship and have had many conversations about photography, our tropical homes and travel. On one particular day, during one of our telephone conversations, I finally felt comfortable enough to ask her about her past.

"So, seriously," I began, cradling the phone on my shoulder and settling into my cup of tea, "you left home at seventeen? How did your parents not freak out?"

"I did!" she laughed, speaking in her charming accent. "I think my parents always knew I was different."

"Tell me about them." I said. "You're from São Paolo, correct?"

"Yes. We're a very close family — I have my parents, of course, and then I have a sister who is five-and-a-half years younger than me."

"What was it like growing up in Brazil?"

"I had a pretty typical middle class childhood, I would say. My dad worked at the electric company — he'd worked there since I was fourteen. My mom was a secretary for many years, but she also did a lot of crafts, and she had an affinity for landscape design. We had a very simple life; although they both worked full-time, we didn't have a lot of money. But they invested all their pay in our education and well-being.

"My grandparents lived by the sea," Alex continued. "We visited them every weekend. We'd drive an hour and a half — that's very typical for the people of Sao Paolo, to visit the seaside on weekends. My favorite thing was to spend entire summers with my grandparents at the beach. My life was happy, but simple."

"Did you guys ever travel as a family?"

"Not out of the country," she replied, "but my parents loved long road trips. They loved traveling and exploring the country, taking long trips all along the coasts. We traveled a lot together inside of Brazil.

"But me, I was the oddball. I'd always been fascinated with other cultures and other countries. I always loved geography books and maps. I remember we had this sort of — encyclopedia collection, I guess — where each book in the set featured a different country. I remember I would sit in my bedroom for hours, reading the books and looking at the pictures ..." she sighed.

"So? When did you finally get to fly away?"

"Well, so I'd been studying ballet since I was about five ..."

"... wait, what? You danced? Seriously?"

"Yeah, up until my early twenties actually." This was the thing about Alex: in any given conversation, I was likely to learn something new and astonishing about her. "So yeah, anyway, I'd been studying ballet pretty seriously, and the ballet school I'd been attending was affiliated with the Royal Academy of Dance, in London. So every year, we would go through a formal examination, and our teachers would often show us videos of English ballets."

"Because of this, I always had this idea that England was the place to watch ballets (and, it turns out, it is).

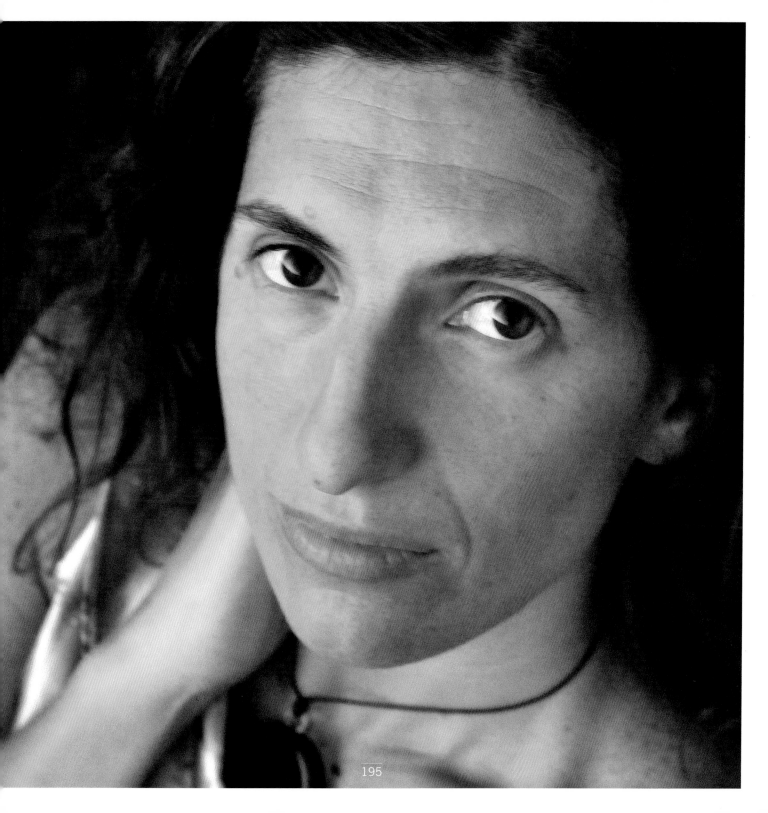

So even though my parents don't speak much English at all, my parents were determined that my sister and I would learn English. So we both attended after-school classes at a British school, for years. One day, my parents noticed an opportunity in the paper to win a scholarship to study English in England, and so, since they knew how fascinated I was with England, they encouraged me to apply. I did. And I got the scholarship."

"How exciting for you — at seventeen? Your parents were pretty awesome to encourage you to do this."

"Yes, they were very supportive of my dreams, even when those dreams seemed so out of reach. The classes were to be held at a school in Bournemouth, and the school arranged for me to live with a family there for three weeks. While I was there, I became friends with this twenty-eight-year-old Brazilian woman, Deborah, who was about to travel Europe, so I asked if I could go with her after the course was over. Even though she was ten years older than me, she said yes. As it happened, my mom had a friend of a friend whose sister, Marta, lived in London, so I traveled to the city to meet her and ask her if I could drop my main luggage at her house so I could backpack around Europe with Deborah. When I spoke to my mom, she was okay with the idea since the trip was just meant to last about a month."

"Oh." I frowned, thinking of my own five-year-old daughter; I'm not sure I'll be ready to let her travel by herself around a foreign continent when she's just a teenager. "I can't believe your parents weren't more worried."

"Well, they were understanding, and they trusted my ability to take care of myself — I can be very persuasive! So I left all of my luggage and things with Marta, and I took off with Deborah. I went all over western Europe for about a month — the only country I didn't visit was Portugal."

"That's funny. The only country you didn't visit was the one where you knew the language?" As I said this, I realized that I likely would have done the same thing.

She laughed with me. "Portugal was just too far south for the amount of time I had. It was great — I backpacked and stayed in hostels for about a month. You have to understand: although the concept of a year abroad after high school is common in some countries, it isn't something Brazilians generally did twenty years ago — just take time off to travel the world. I was lucky to have the opportunity.

"When I returned to Marta's house, I was full of stories, and I told her everything that happened on my trip. When she saw how excited I was, she asked, 'Why don't you stay? Stay with us for a little longer and have an adventure!' So I did!"

"You're kidding."

"No. I had the time of my life, and Marta and I formed a very special bond, which we share to this day. I got to know London really well. I visited the Royal Academy of Dance, which was such a big dream of mine. I watched many ballets. I made friends and I explored. It was fantastic.

"Eventually the time approached when I had to go home. Before I had left for England, I had applied to university in Brazil, and I had been admitted to one particular college to study medicine. So I was supposed to return home to start my education, but the longer I stayed in England, the more I realized that I didn't want to be a doctor — it felt too limiting."

"Limiting? Really?" I mused. "I don't think most people would say that studying medicine was limiting … "

"It definitely would've been for me," she countered. "Studying medicine, I would've been too immersed in science books. While traveling through Europe and immersing myself in art, history and other cultures, I realized that I was much more drawn to the liberal arts. Besides, I wasn't ready to make such a long-term commitment to a path in medicine. Anyway," she remembered, "all I really wanted was to stay in England and have an adventure. I felt open and I wanted to expand my horizons and see what else would turn up for me."

I remembered a time a decade earlier when I had made the decision to move to England. I'd actively sought a job opportunity within my company to move overseas; after having lived in Houston for a decade, I was feeling stagnant. I knew the city like the back of my hand, and it had gotten to the point where everyone looked familiar; in a city of millions, I felt like I was seeing the same faces everywhere I went. I was young, single and desperate for an adventure, for the opportunity to go to a new place, experience new things, push myself to navigate a new city and make a new home somewhere. I knew exactly what she meant.

"So, you told your parents?"

"Yes." Her voice grew more serious. "They started to panic. They thought I would never return to Brazil. 'You have to come back!' they insisted. But I really wanted to stay. I started trying to figure out ways I could make the experience last longer, even though I'd already been there for three months by that point."

"Was there a boy?" I teased.

"No, actually, there wasn't," she answered. "I had absolutely no notion of boys. I just wanted to explore. Travel. I was interested in the world.

"But then, one day, my father called me, really upset. I remember he said, 'Your mother is sick, worried about you, and she will end up at the hospital if you don't return.' It was awful. I really believed England was meant to be my place, but I was worried about my mom. So I returned home."

"God, you must have been miserable."

"I was. I was really unhappy for the next year or so after I returned. In fact, as soon as I came home, I began planning the next trip. Since I decided that I didn't want to go to medical school, I instead signed up for advertising because it encompasses many art forms — copywriting, art direction, illustration, photography, video, music … so many. At the time, Brazilian advertising was very hot, and I thought that having an education in advertising would allow me to write, design and connect with very creative people. Also, the studies wouldn't be too intense, so I could intern in the field and keep up with my English studies and ballet.

"So, I started teaching English in local schools. I worked for ad agencies and multinational corporations, including Kodak, which is where my interest in photography started. At the time, digital photography was becoming popular, so I was entranced.

"Once I finished my degree, I started looking for art schools in England — but also in other English-speaking countries. I wanted to study in a formal art school, but I also wanted a school that had a strong technology focus. Back then, I couldn't find a school that fit these requirements in England … but I found it in Savannah, Georgia."

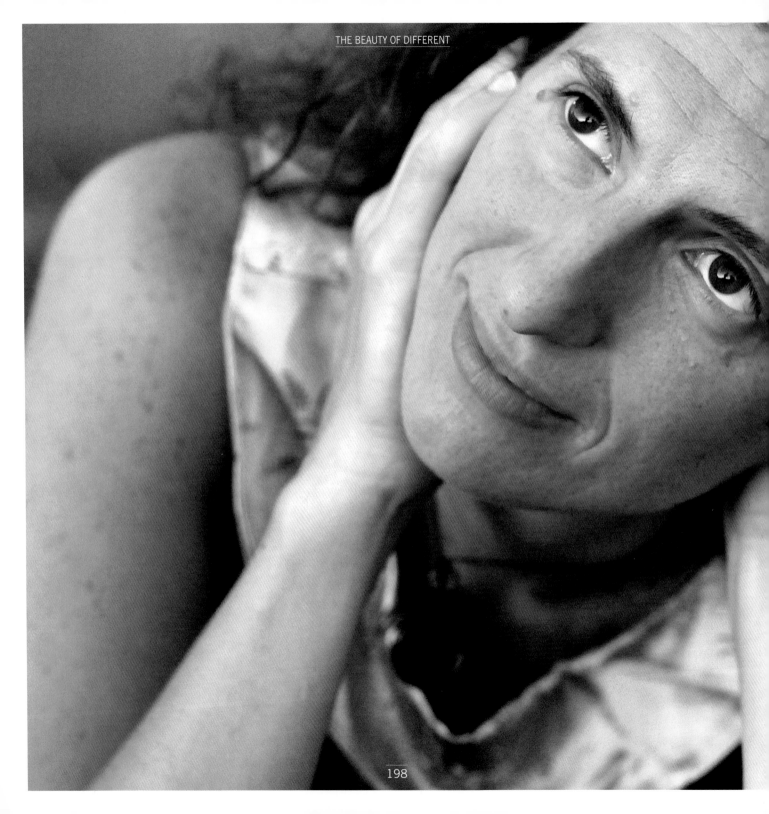

"Really? Georgia's kind of far away from England ..."

"I know! But Savannah College of Art and Design was really well equipped with high-end facilities and labs, and besides — Savannah had the same Victorian charm that I'd fallen for in England. I took that as a sign.

"So, I convinced my parents that going to the United States would be good for my career. My mother, by this time, had come to realize that I was intent on living overseas, and so now that I was older, she acquiesced. So I went. I got my Masters in Computer Arts, which includes both 2D and 3D animation. When I graduated, I immediately began to look for work in the United States since I had a practical training visa, which was valid for one year after graduation. I moved to Los Angeles with the help of a good friend I'd met at school, and then a few months later, I received an opportunity at a 3D animation studio and visual effects company in Berkeley, California. So I moved north, worked my way up the ranks and eventually became a visual effects producer over the past ten years."

"So you've been in the United States this whole time. Did you ever travel again?"

"Oh, absolutely. I traveled for work, but I also traveled for pleasure as much as possible. Every time I had any spare time in between movies, I traveled. I traveled all over the United States; I went to Canada, Belize, Guatemala, Mexico and Argentina. I traveled to Thailand, Indonesia, Hong Kong and New Zealand. I went back to Europe a few times. I spent six weeks in India, traveling from Kerala in the south, all the way to Jaipur and then north to the Himalayas. I spent a week in an ashram. It was amazing. I also went to Australia twice. I traveled extensively on the coast and in the outback, and I even spent three months living in Melbourne while shooting the movie *Charlotte's Web*. My passion for travel has never waned. It never will."

"This passion for travel — what do you think it's taught

you? What has travel given you?"

"Well, Asia is where my love and passion for photography truly flourished. I remember spending many solitary moments with my camera in Thailand that were truly special. And India — well, India was just visual overload. It is hands down my favorite place to photograph. So much color everywhere. And each part of the country felt to me like an entirely new planet. I really want to go back one day and work on a documentary project there."

"Always looking for a new adventure, eh?" I smiled.

"Well … yes. I love adventure. I think adventure happens when we embrace possibility, whether there's travel or not. I like to live with the feeling that anything is possible, that the world — and life — is our playground. And adventure is tied to my superpower; I think my superpower is my ability to believe in my dreams and make things happen. It is my natural instinct to push myself farther, to constantly test the limits of my comfort zone. I suppose that's why I've traveled as much as I have, and from such a young age. And then, in hindsight, I realize that it all came to me so naturally. I need adventure. It's just part of who I am. And while I don't ever need to be famous or wealthy, I do need to always do what feels authentic to me, you know?"

Yes. Yes, I do know.

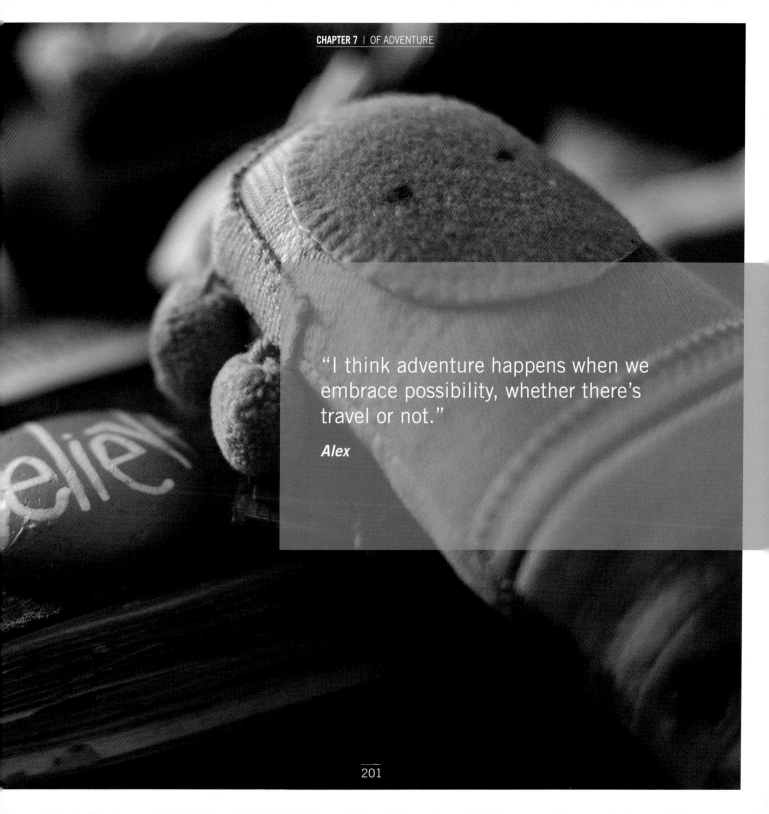

"I think adventure happens when we embrace possibility, whether there's travel or not."

Alex

Dream

I have this recurring dream. In this dream, I'm walking along, minding my own business, when all of a sudden I feel myself rise, hovering just about a foot or so off the ground. At first, I'm petrified: I start flailing my arms about, afraid of falling, and I reach out for something — anything — to steady myself; but eventually, I begin to realize that I'm not going to fall, that I'm not in danger of being hurt, that I'm going to be fine. And that's when a smile starts to creep across my face.

I lean forward like I'm about to swim, and as expected, I begin flying. I experiment: I learn how tucking my body in a fetal position slows me down and extending my body straight and taut makes me go faster. At first, I only fly about five or six feet off the ground, following the streets and the sidewalks; eventually, I become emboldened and go higher, flying over rooftops and trees and going faster and faster until finally I have no choice but to scream at the top of my lungs in unbridled joy.

After I've flown to my heart's content, I return to the street where my flight began and start walking again, going about my normal day. But deep inside, I feel smug, knowing that at any moment, if I wanted to, I could soar again.

I don't know what the technical interpretation of this dream would be — I've never been much into that sort of thing anyway — but I always take it as a sign that it's time to insert a bit more adventure into my life — take a trip somewhere unknown, try a new hobby, even eat a strange new food. Because really, there's nothing like experiencing something you've only dreamt of doing and making that goal and going after it to make you feel invincible.

It feels like flying.

Light

As is likely true with any photographer, when I shoot I'm very conscious of how the light is flowing, the shadows it creates, the reflections that occur. But sometimes, I become fascinated with how things look through the light; I find myself squinting into the sun, blinking back tears, shooting the translucence of leaves and petals, capturing the flare.

It occurs to me that sometimes that's how life feels when I have a goal or a singular purpose, or when I'm embarking on an adventure. Whenever I've wanted something really badly, it has never come to me easily; in fact, I've become very superstitious in the belief that if things come to me without any real effort, then ultimately, I'm going to be disappointed. Only the things I've had to really struggle for have turned out to be exactly as I'd hoped, to be the adventure I dreamed of.

And so, the images that I capture of the light are often my favorites; they remind me that when I'm working on something, embarking on a new adventure, straining with effort and even blinking back tears, as long as I keep the result in mind, it'll all be worth it in the end.

of agelessness

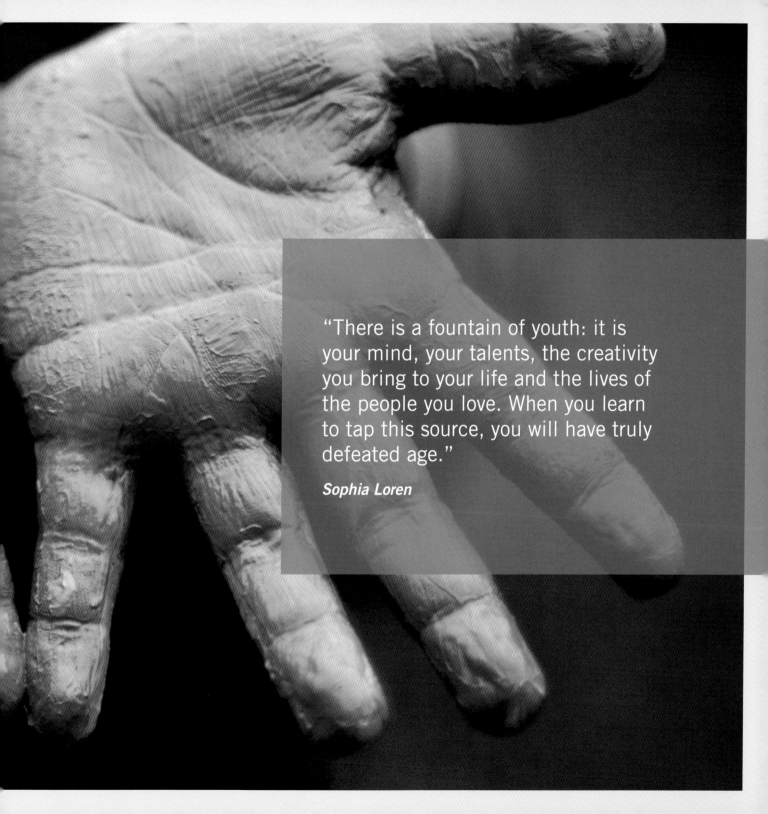

"There is a fountain of youth: it is your mind, your talents, the creativity you bring to your life and the lives of the people you love. When you learn to tap this source, you will have truly defeated age."

Sophia Loren

Views on Agelessness

Twenty Truths I Wish I'd Known Twenty Years Ago

1. It is never a mistake to try something, even if it doesn't work out the way you planned.
2. You can never get in trouble by thoughtfully, respectfully speaking your mind.
3. It's never too late to change who you are, as long as by doing so you're becoming more authentic.
4. Being kind is never wrong, and being a doormat is never right. The trick is doing the one and avoiding the other at the same time.
5. Help someone every day, even if it seems like an insignificant gesture. It may matter to that person more than you can fathom. And one of the greatest joys in life is helping another person succeed.
6. True sexiness and sensuality have so little to do with body measurements.
7. Physical health depends more on internal happiness than most of us realize.
8. There's always a kind way to tell the truth.
9. There's no such thing as an uncreative person. There's just someone who clings to a narrow definition of "creativity."

10. The most important practices are meditation, movement, learning and gratitude. Do each, in some form or fashion, every day. And if doing one of the four qualifies as "play": bonus points.

11. Be Yourself, but when reducing Yourself to writing (either on paper or on a computer), reduce Yourself to the Best You Possible. Both paper and the Internet have very long memories.

12. There is very little that five minutes of steady, deep, focused breathing can't improve.

13. All of us, no matter where in the world we happen to be, should travel to a foreign country alone at least once. It's good for the soul and for the perspective.

14. There will always come a time when the choice must be made to either do it "the way it has always been done," or the way your soul tells you is right. No matter how initially painful, doing what is right always feels best in the long run.

15. A heartfelt dream combined with belief and hard work always results in success — even if the outcome is unexpected.

16. Never believe what people tell you that you were "meant" to do, or what they say you were "cut out" to do. Ultimately, you are the only person who knows. Everyone else is invariably wrong.

17. If you're going through a rough patch, now is a perfect time to treat yourself like you would treat a friend going through a similar situation. I find a double-decker ice cream cone can do wonders.

18. When it comes to fashion and beauty, magazines are sources of inspiration, not playbook rules. Use accordingly.
19. Labels are for the unimaginative. Reject labels. Do what you are called to do.
20. People don't age because time passes. They age because they forget to look at the world with wonder. Never stop looking for the wonderful.

" I'm different because I can twirl fire batons. "

Laura

214

“ I'm **different** because I'm **nineteen** and I have a lot of **gray hair**. I've had **them** for **years.** ”

Andreína

"I'm different because when I need an extra boost of confidence, I play and dance to my theme song — 'You've Got the Look,' by Prince."

Kat

"I'm different because **I look** perpetually **mischievous** — even from miles away.**"**

Adam

A Closer Look: Pam

I don't remember how old I was the first time I heard my mom lie about her age. I was young, though — *very* young — seven, maybe? Eight? In any event, I came home from school, proudly telling her that I had informed my classmates how old she was. She looked at me in horror.

"Karen, you must *never* tell your friends my age," she said.

"Why not?"

She looked flustered. "You just *don't.* And if they insist, you tell them I'm twenty-nine."

"But …" I was confused. "I thought you were thir — …"

"Just tell them I'm twenty-nine," she insisted. And then, more wistfully: "Twenty-nine was a wonderful age …" she murmured, and she walked away in reverie.

Even then, I thought lying about your age was quite possibly the craziest thing I'd ever heard. I mean, from my perspective, I couldn't wait to get older — why in heaven's name would you ever try to make yourself seem *younger*?

For the most part, I've continued to believe this my whole life; I've never shied away from telling people my true age, nor have I ever greeted my birthday with anything but happiness. Yet, as time passed — and gray hairs started to appear, body parts became softer and more dimply, and my backside began its slow march down the back of my legs — I began to see my

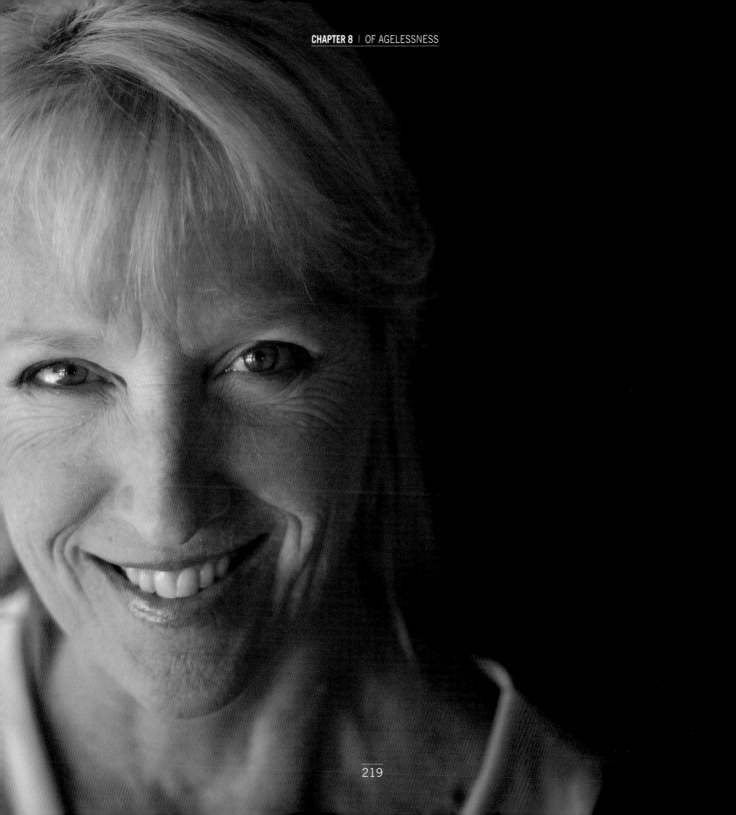

mother's point. I still don't believe that lying about my age is going to fool anybody; yet, if I sit and think about it, there's no escaping the truth: sometimes, aging isn't fun.

But whenever I do find myself sitting and thinking about it, before long my mind invariably turns to my friend Pam, a woman who flat-out defies age. It's not just that she looks great for her fifty-seven years — although, Sweet Pete, she really does look fifteen years younger — it's that she seems to be completely oblivious to any of what it stereotypically means to get older. She doesn't just look or act young, she is young. In fact, she is quite possibly the youngest person I know. And since I'm the mother of a kindergartener, that's really saying something.

I met Pam many years ago at the end of my first marriage. I was in my mid-twenties, and she was my new next door neighbor in the wooded apartment complex where I had moved exactly 50% of the stuff from my previous home. It was a pretty stressful time for me: it was the first time I was living on my own as an adult, I was dealing with a divorce, and I was just beginning my legal career. I was as unhappy as I'd ever been, so having a kind neighbor with a soulful smile and eyes that danced with fun was exactly the sort of tonic I needed.

I soon learned Pam was a very spiritual person — she was well-versed in Eastern philosophies and religions — and she had the most diverse set of hobbies of anyone I'd ever known. While most of my friends and I spent our spare time lifting weights at the gym, Pam was doing standing meditation or slow Eastern Martial Arts sword practice on the sidewalk outside of our homes. While I ran incessant circles around the track at our city park, Pam took flamenco lessons. When I escaped to relaxing vacations spent idly on a beach, Pam visited coastlines with huge swells so she could tackle them with her surfboard.

I may have been younger than Pam, but the truth was that she was the kid.

Several times over the years, I've asked Pam how it was that she never seemed to age. "Why age?" she would look at me with mild distaste. "I've never stopped liking to play and have fun. In fact, I won't ever stop liking to play and have fun."

Pam comes by her thoughts on aging honestly: her parents were (and still are) the same way. "I remember, growing up, Friday night was always Party Night," she told. "They threw these really great parties. And when my brother and I were teenagers, my parents would sneak out to the lifeguard stand on the beach to make out." She rolled her eyes at the memory, and began to giggle. "Friends would go, 'Um, Pam? Are those your parents...?'"

Pam spent most of her childhood in Hollywood, Florida. The daughter of a crime scene investigator and a buyer for a record company, Pam spent her youth surfing up and down the northern Florida coast. She was bitten by the travel bug when she was in high school. "I always wanted to be in the travel industry," she says. Her dream was to surf the big swells of Hawaii — and when she was twenty-three years old, she bought herself a one-way ticket to live her dream.

"Wait, you just left? Did you have a job? Plans?"

She laughed. "Nope. I sold everything, and went. I just knew that Hawaii was where I was supposed to be and trusted that it was all going to work out."

"So what happened?"

"Well, I landed in Maui, got my bags and got in a cab. The cabbie asked me where I wanted to go. I didn't have any idea, so I told him I was looking for suggestions. He suggested the Pioneer Inn, which was this old whaling hotel on the other side of the island. I said, 'That works!'

"The drive to the hotel took about an hour, and so the cabbie and I started talking, and he asked what I was going to do while I was in Hawaii. I told him that I didn't know and would be looking for work. After the end of the hour's drive, he spoke to his wife, and they offered me a job to babysit their little boy. For three months, I lived with this guy's family, taking care of his son and surfing on my time off. It was great."

Eventually Pam moved to the Big Island of Hawaii, where she got her first job as a travel agent. "My first job was heaven: I was in a beautiful environment, helping people have their best possible vacation. I wore shorts and rode my bike to work, carrying my surfboard with me! During lunch I would surf, then shower off and go back to work, totally invigorated." She worked for several years on the Big Island, before feeling the call of the mainland again — which is how she eventually found herself in Houston and as my next door neighbor.

One day Pam was sitting on my living room sofa, drinking tea, looking as radiant as ever. "Pam," I said, "do you ever think about your age? Getting older?"

"No, never," she responded. "I remember once when I was a kid, my mom was in the bathroom looking at herself in the mirror. She was about thirty-three at that time, and I remember her saying — without any regret or remorse, just telling me matter-of-factly — she said, 'Babe, don't ever get old.' I took it to heart. And so I've never really focused on age — I sort of see myself as whatever age I need to be to do whatever it is I want to do.

"I think there are really three ages that everyone has," she continued. "There's your chronological age, which is of course, the number of years you've been on this Earth. Then there's your physiological age — sort of the age that your body feels — but then there's your psychological age. That's the age that you *feel*. And I figure my psychological age is about fifteen," she grinned.

"Okay, but let's just talk about that physiological age," I said, not willing to give up that easy. "A few years ago, you had hip replacement surgery, right?"

"Yeeessss," she said, looking at me quizzically.

"Well? Didn't that make you feel like you were aging or getting older?"

Pam looked at me, genuinely confused. "Oh. No. No, not at all," she said. "I mean, I've danced since I was three-and-a-half years old — you know, ballet, and even flamenco. And I've surfed and always been really active. The reason that I had to have hip replacement surgery was because my hips were genetically predisposed to only withstand so much stress, and I'd been working them pretty hard. I don't think it had anything to do with age …"

"You're amazing, Pam," I said. "I think most people would think of hip replacement surgery as a sign of getting older."

"No, I really never thought about it that way," she said. "For me, it was just general maintenance because of a genetic quirk."

"And it's never slowed you down from being active, has it?"

"No way," she said emphatically. "You know, there's this saying … what is it? … something like, 'Do the things you fear, and the death of fear is certain.' I love this. I think this is all part of staying young. Take travel, for instance," she continued. "Traveling takes you out of what is familiar and forces you to embrace change as you experience different lifestyles, cultures and people. I think that openness to experience something new keeps us from being stagnant, dull, or … well, *old*."

"I agree with you when it comes to travel," I conceded, "but the concept of facing fear helping to keep you young … I don't know. I think a lot of people would think that fear, or stress, or worry would actually *age* you …"

"Oh, stress and worry definitely ages you, but I really believe that facing fear results in growth and strength; it vitalizes. Like back in Hawaii, I faced my fears each and every time I hit the water to surf — sharks, hitting the reef,

drowning, were all very real possibilities. I felt that knot in my stomach every time I entered the water. But then, as soon as the first wave washed over me, I was always compelled to say, 'Oh, thank you God.' It was as if the wave washed away any problems, any worries. And then when I finally hit the beach at the end of the session, I was *thrilled* … thrilled with myself for doing it in the first place, thrilled with the beauty of nature.

"These days, I don't surf very often, but my 'ocean' is my Harley. It's a lot like surfing actually: I still get that 'knot,' or awareness of the danger of riding each time before I get on the bike. I say my prayer for protection from harm or injury, and by the time I'm hitting second gear, the wind is blowing my hair, and I'm saying, 'Oh, thank you, God.' And then, when I pull my bike back into the garage, I give myself a sort of mental 'high five,' for defeating fear and going for the thrill, for pushing myself and my comfort zone."

"You mentioned 'God' a few times there," I smiled. "I know you've studied so much Eastern philosophy, so I was wondering: how much of your attitude about aging has been formed by that, do you think?"

"I'm Christian," she said, "and have a very strong faith as a result; but yes, I've always been interested

in Eastern philosophy. Regardless, however, I think I've mostly come to my outlook on getting older from my parents; I was raised by people who loved life and loved having fun. Still, there's probably some truth to the idea that perhaps it has helped me have a healthy outlook on getting older — mostly because there's the philosophy of mindfulness and living in the present that is really my core belief. I'm always about living in the now, living in the present — I mean, who knows if you're going to live tomorrow, you know? I'm always living in the present, not looking back with regrets or guilt, or to the future with any anticipation or anxiety. I mean, I still plan and have dreams and goals, but the majority of my day is spent right here, right now. I just trust God that everything is going to be fine."

After my friend left my house that day, I couldn't help but sit and think about what she had said; it wasn't the first time that I'd heard that "living in the present" was the cure to much unhappiness, but I hadn't considered it when it comes to dealing with the prospect of getting older. It made sense somehow: by really appreciating the life I'm living, the life I have *right now,* enjoying the moment I'm spending steeping your tea, or

"Why age? I've never stopped liking to play and have fun. In fact, I won't ever stop liking to play and have fun."

Pam

anniversary May 31.
Blosch and the former
Lorraine McMillon were
married May 31, 1947, in
Philadelphia. They are
parents of two, Pam Blosch,
Houston, and Dennis Blosch,
ashville, Tenn., and they
ve two grandchildren.
On their 25th anniversary
celebrated in Paris

making the bed, or even reading a book, it's sort of hard to also concentrate on what life might or might not be when I'm older. At that moment, I made the commitment to myself to be more conscious of the goodness around me in the present as often as possible in my day-to-day life.

And perhaps by doing so, the next time someone asks me how old I am, even though it would never dawn on me to lie about it, I'll answer in a spirit of celebration.

On the Morning of

Wednesday, January 27, 2010

"Hello?"

"Hi, Mom. May I speak to my father, please?"

Laughter. Then more formally: "Yes. Of course. One moment please."

"Hello?"

Singing, rather badly: "Happy Biiirthday to yooooou! Haaaappy Biiirthday to yooooou! Haaaappy BIIIIIRTHday dear DAADDDDDY! HAPPY BIIRRRRTHDAY TO YOOOOOOU!"

More laughter: "Thank you so much!"

"Happy birthday, Daddy. How are you doing today?"

"Thank you, Child, I'm good! You know, I'm officially in my seventies now …"

"Right on. You're a big boy!"

"I am indeed."

"What are you going to do today?"

"Well, I'm practicing my flute right now, and then in a minute, I'm going for a bike ride — twenty miles today. Then I'm going to come home, shower, and then sit down and make a list of all the things I want to do in the coming years."

"Yeah? Like what?"

"Well, like a few lectures I want to give. And then there's a high school downtown that's pretty interesting, and I want to put together a proposal to submit for some volunteer work I think I could do there, and then … well, there's tons of things. There's still so much left to do, you know?"

"I know, Dad. There always is."

Play

I spent the summer between high school and college hanging out with a group of six friends with whom I'd grown close during the three months before graduation. We used to hang out at my friend Kathy's house. Her parents had converted the garage of their modest, mid-century home into a large bedroom and living room for Kathy, and the space included its own private entryway from the outside, making it the perfect, grown-up-feeling place to hang out (and, of course, her parents were usually inside, so it wasn't likely we'd get into too much trouble as a result). We spent many weeknights just sitting around, eating pizzas and dreaming about our futures at the various universities to which we were headed in the coming fall. And more often than not, we wondered if this was the beginning of the end of our youth.

"Well, I don't particularly care, personally," sniffed Kathy, one particular evening. "I can't wait to be an old, old woman."

"Why's that?" I asked, my mouth full of pizza.

"Because when you're an old woman, you can get away with murder," she said, quite seriously. "You can curse like a sailor, you can pinch the asses of random cute guys, and no one says a word. They just chalk it up to your being old and crazy, and all the while you're amusing yourself, having a great time and totally getting away with it all. I can't wait to have that kind of freedom."

The six of us burst out laughing, agreeing that the freedom of an old woman, as defined by Kathy, was definitely worth living. But I remember that night wondering: when exactly is the age when you can start pinching asses and cursing like a sailor and not have to account for your behavior? Was it at seventy-five? Eighty-five? And more importantly, until you reached that age when you were allowed to express that freedom, were you required to toe the line and behave As Society Expected You to Behave, no questions asked, thank you very much?

Fast-forward twenty-five years, and I've come to believe that youthfulness is all about spending your entire life trying new things, testing the boundaries of what it means to be authentic and true to yourself and maybe, just maybe, having a little fun along the way. I believe that perhaps the reason that the old woman my friend envisioned gets away with it is because she was constantly exploring, spending her time looking for ways to amuse herself, so that it just was never a shock at her advanced age when she did something out of the norm.

As for me, I've made it a goal to constantly look for ways to have fun, to play, and to encourage the people around me to do the same. It can't hurt.

At the very least, I'll learn at what age I can pinch the asses of random cute guys and get away it. And I'll be sure to pass that information along when I do.

afterword

"Beauty appears when something is completely and absolutely and openly itself."

Deena Metzger

When I first began exploring beauty, I mean really exploring it, my intent was to collect some pretty images, listen to the stories of ordinary people and generally expound on my theory that the things that make us different are also the things that make us all beautiful. My ultimate goal, in all honesty, was to create a collection that was both interesting and pretty — and maybe, just maybe, something from all this work would speak to readers and viewers on some level, in some way.

What has happened, however, and what I didn't expect, was how much the exercise of collecting the images and listening to the accounts from strangers and friends alike has impacted me. I knew that I would hear interesting stories, but I didn't expect to find them so special. I knew that these individuals would be generous with their thoughts, but I didn't expect them to share their spirits as willingly as they did. And while I suspected that I would feel a connection with them, I understand now that I didn't — I couldn't — have predicted how beautiful I found each of them to be. I've now convinced myself that my theory is, indeed, fact.

So, as I send their stories and images out into the world, it is my fervent hope that after meeting all of the extraordinary people in these pages, learning their stories and discovering their Differents, you have a renewed, energized perspective on the characteristics that make you Different and that you have a stronger, more hopeful sense of self. I hope that you're motivated to let the beautiful people in your life know what it is that you find makes them Different and therefore so special. I hope that you see the limitless potential of your own future, once you've framed your honest and authentic Different in a positive, powerful light.

What I can tell you now, even though you and I may have never met in real life, I know — I am certain — that your Different is very, uniquely beautiful.

— *Karen Walrond*
Houston, Texas

an index
of beautifully
different words
and images

IMAGES

with appreciation
for some beautifully
different people

ACKNOWLEDGEMENTS

*T*his is the very first book I've ever written in my life. Oh, I did write one when I was about eight years old, something about a young girl and her mango tree, but the less said about it the better. This is the first real book I've ever written, and now that it's done, I'm so filled with relief and gratitude I want to thank everyone I've ever known in my entire life, including my elementary school principal and my high school calculus teacher. However, my editor tells me that doing so isn't necessary, so I won't. But Mr. Sumpter and Ms. Volkmer, if there's even a hint that my editor is going to change her mind, I'm totally gonna thank the hell out of each of you.

Instead, and for now, I would be positively remiss if I didn't express my appreciation for (in no particular order):

- Lucy Chambers and everyone at Bright Sky Press, who took me seriously when I told them I had an idea for a different little book with the potential of being beautiful, and then they went and actually turned it into something even better than I imagined;

- all the beautiful people who let me photograph their different faces for this book, but most especially Helen, Patrick, Laurie, Jenny, Allen, Irène, Alex and Pam, who were astonishingly generous with both their stories and their spirits;

- John Allen and Brad Hill, two former bosses who, instead of taking it personally when I told them I didn't want to work for them anymore, continued to give me sound advice and kind counsel as I tried to figure out what I wanted to be when I grew up;

- the LoveBombers, who generously shared their time and their support, and showed me by example that living an authentic life and embracing my Different was the only way to go;

- my Houston posse, especially Laura Mayes, Jenny Lawson, Katherine Center and Brené Brown, for both hugging me fiercely and smacking the snot out of me when it was both appropriate and necessary;
- the Walrond and Jennings families for their unerring support;
- my daughter Alex who, whenever I couldn't decide between two images, invariably picked the right one; and my husband Marcus who took such good care of me during the long days and nights of writing this, and who insisted the book wouldn't be a success without including the word "kippers" — and now that I look at it here in print, I see that he is clearly correct (I love you both) and
- the thousands of readers around the world who visit me at *Chookooloonks.com*. I have loved all of your emails, comments and encouragement. Each day I put a little bit of my Different out there on the internet for you to see, and you've never — not once! — pointed and laughed.

It is in gratitude to all of you that I wrote this book.

Thank you.

" I'm different because I'm really good at spotting the beauty in the everyday. "

KAREN WALROND is a writer and a photographer. Her writing and images have appeared in exhibits and publications around the United States. She is a sought-after public speaker who has covered topics as varied as personal empowerment, women in leadership, social media and parenthood. She has appeared on both local and national television shows, including "The Oprah Winfrey Show."

Karen is also the author of *Chookooloonks.com,* an award-winning site that has existed in various forms since February 2004. *Chookooloonks.com* provides daily photographic proof that beauty can be found anywhere, every day. The site helps thousands of readers from around the world see that their ordinary lives are, in fact, extraordinary.

The Beauty of Different is her first book.

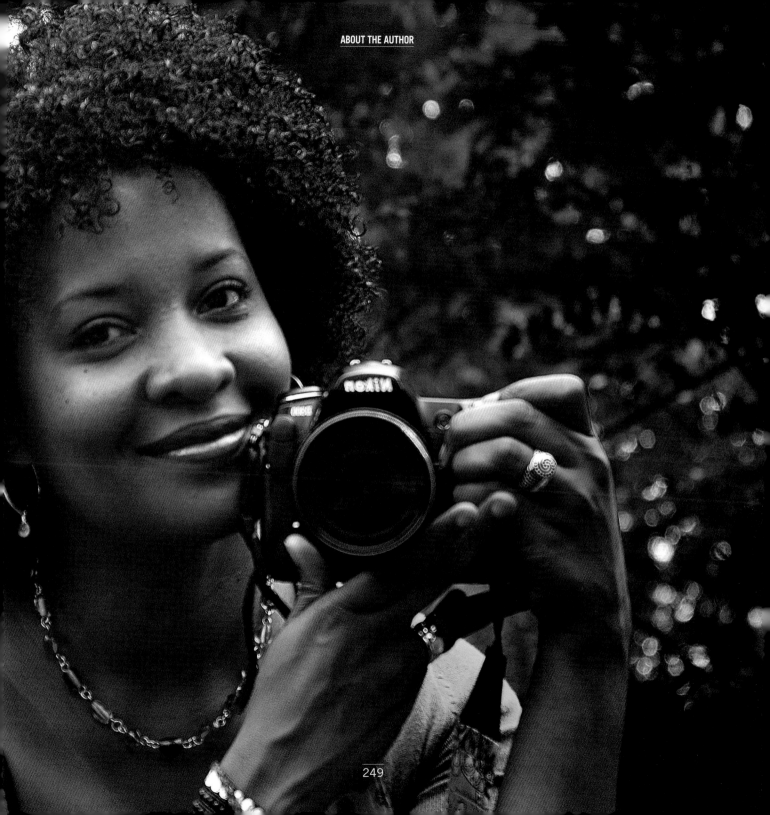

What's your Different?